AFRICAN AMERICAN MASTERS

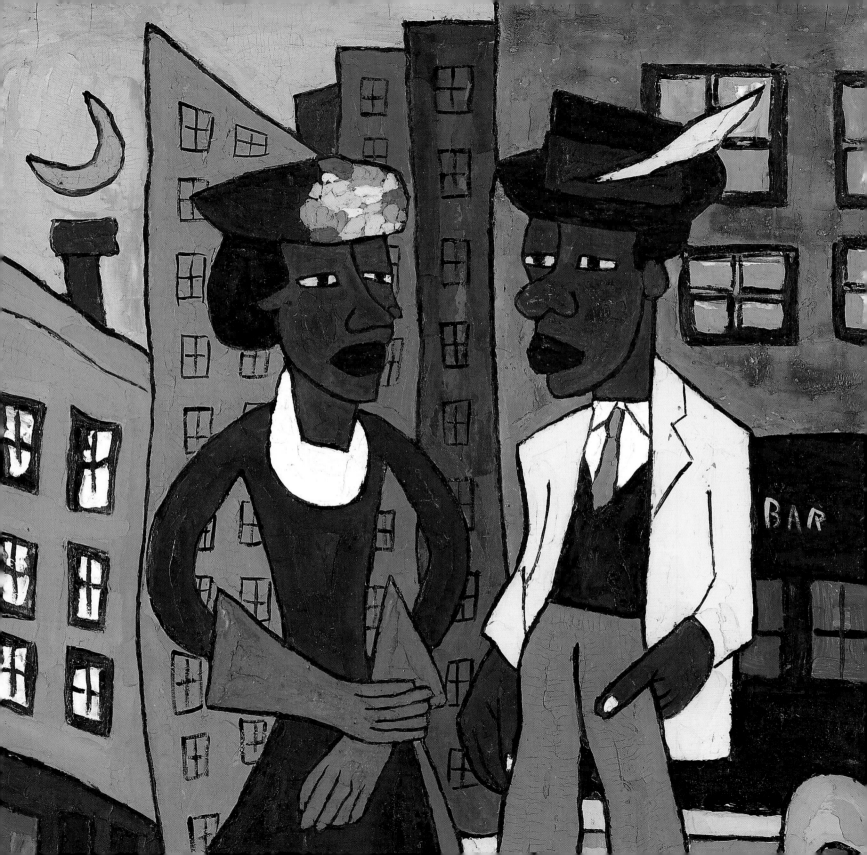

AFRICAN AMERICAN MASTERS

Highlights from the
Smithsonian American Art Museum

Gwen Everett

Harry N. Abrams, Inc., Publishers, New York

Smithsonian American Art Museum

African American Masters: Highlights from the
Smithsonian American Art Museum

By Gwen Everett

Chief, Publications: Theresa Slowik
Designers: Robert Killian, Steve Bell
Editor: Timothy D. Wardell

Library of Congress Cataloging-in-Publication Data

Everett, Gwen.
 African American masters : highlights from the
Smithsonian American Art Museum / Gwen Everett.
 p. cm. — (Highlights from the Smithsonian
American Art Museum)
 Includes index.
 ISBN 0-8109-4511-8 (hardcover)
 ISBN 0-937311-55-3 (pbk.)
1. African-American art—20th century—Exhibitions.
2. Art—Washington, D.C.—Exhibitions.
3. Smithsonian American Art Museum—Exhibitions.
I. Title: Highlights from the Smithsonian American
Art Museum. II. Smithsonian American Art
Museum. III. Title. IV. Series.
 N6538.N5 E84 2003
 704.03'96073'0074753—dc21
 2002154511

Printed and bound in Spain

First printing, 2003
1 2 3 4 5 6 7 8 9 / 08 07 06 05 04 03 02 01

© 2003 Smithsonian Institution
First published in 2003 by Harry N. Abrams, Inc.,
Publishers, New York, in association with the
Smithsonian American Art Museum.

Cover: Romare Bearden, *Empress of the Blues* (detail),
1974, acrylic, pencil, and printed paper. Smithsonian
American Art Museum, Purchase in part through
the Luisita L. and Franz H. Denghausen Endowment
(see page 16)

Frontispiece: William H. Johnson, *Street Life, Harlem*
(detail), about 1939–40, oil on plywood. Smithsonian
American Art Museum, Gift of the Harmon
Foundation (see page 54)

African American Masters is one of five exhibitions presented as *Highlights from the Smithsonian American Art Museum,* touring the nation through 2005.

Foreword

Working in a museum, I have come to appreciate the joys of repeated encounters and easy intimacy with works of surpassing tranquility or great power. I also love the surprise of the unexpected when I see something new or challenging in another museum. Visitors here and abroad share these same experiences, encountering artworks as familiar friends in settings close to home or unanticipated discoveries in different places.

The Smithsonian American Art Museum is the nation's museum dedicated exclusively to the art and artists of the United States. The collections trace the country's story in art spanning three centuries, and its in-depth resources offer opportunities to understand that story better. While our main building undergoes extensive refurbishment, we have a great opportunity to share our finest artworks with everyone across the nation.

From 2003 through 2005, five traveling shows will feature four hundred works, including modern African American art, landscape photography, master drawings, contemporary crafts, and pre-1850 quilts. Readying this wave of ambassadors has called upon the talents and enterprising spirit of the entire staff, especially the curators, conservators, registrars, and editors. I would like to thank all who have worked so hard to make possible this ongoing initiative to share our collections during the renovation period. We are also grateful for the support of the Smithsonian Special Exhibitions Fund and numerous

supporters as well as to the several dozen American museums who will graciously host these traveling exhibitions.

The Smithsonian American Art Museum's holdings in African American art are unparalleled. Once ignored or too narrowly considered, African American art is finally understood as an essential part of America's culture. The lives and works of individual artists—Henry Ossawa Tanner, William H. Johnson, and Betye Saar among them—reveal that historical events, socio-political issues, memory, spirituality, community, and music have collectively enriched this art. Realizing how much courage was required to persevere in the face of adversity can only increase our admiration for the achievements of African American artists. The reasons for celebrating them, however, rest less on ideals of social justice than on the artworks they have produced—so expressive and rich that the larger picture of modern American art would be impoverished without them.

We invite you to revisit our collections as familiar friends when they are installed in the museum's beautifully restored building in Washington, a historic artwork in its own right. There you will encounter expanded spaces for exciting special exhibitions and for the permanent collection's showcasing, including the Luce Foundation Center for American Art. This open-storage facility will house five thousand paintings, sculptures, and craft and folk objects previously inaccessible to the public. A new publicly visible conservation lab will reveal the complex processes of restoring artworks, while an array of public programming and educational resources, onsite and online, will also enhance the experiences of visitors and researchers alike. We look forward to welcoming you to the new Smithsonian American Art Museum.

Elizabeth Broun
The Margaret and Terry Stent Director
Smithsonian American Art Museum

JULES ALLEN

born 1947

Untitled NYC (44th St. and 5th Ave.)

from the series *Hats and Hat Nots*

1990
gelatin silver print
16 x 19 ¾ in.
Smithsonian
American Art
Museum,
Museum purchase

It's the relaxed pose and self-assured swagger of urban black men that interests Jules Allen in this unassuming New York street scene. Like other urban photographers, Allen uses the notion of the decisive moment to reveal the complexity of social interactions. Here, a bare-chested bodybuilder draws the admiration of several onlookers who have paused to watch the sidewalk workout session. Masterfully, Allen leads the viewer from the casual observer on the left, to the man in profile who approaches the weightlifter, to the young man on the right who looks directly at the viewer, as smiling women look on from a bus stop advertisement.

California-born Allen created this among a series of one hundred photographs produced over a ten-year period. The series title, *Hats and Hat Nots,* a word play on "haves and have nots," affirms his tribute to the street-wise ingenuity and dignity of black males.

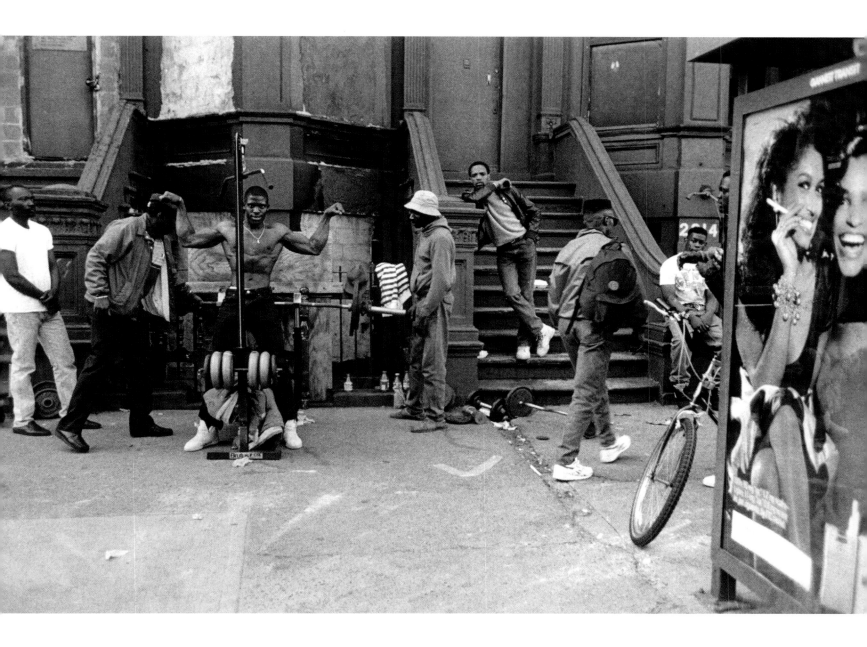

JULES ALLEN

born 1947

Untitled NYC (125th Street)

1992
gelatin silver print
16 x 19 ¾ in.
Smithsonian
American
Art Museum,
Museum purchase

Allen maintains that African Americans "have to understand our right to self-actualization. No one ever chooses the wrong hat." These black Muslims make an imposing ensemble in their suits, hats, and sunglasses. In turning his lens on the concept of strength in numbers, Allen confronts the stereotypical fear of black men in large groups and instead celebrates the power of shared beliefs.

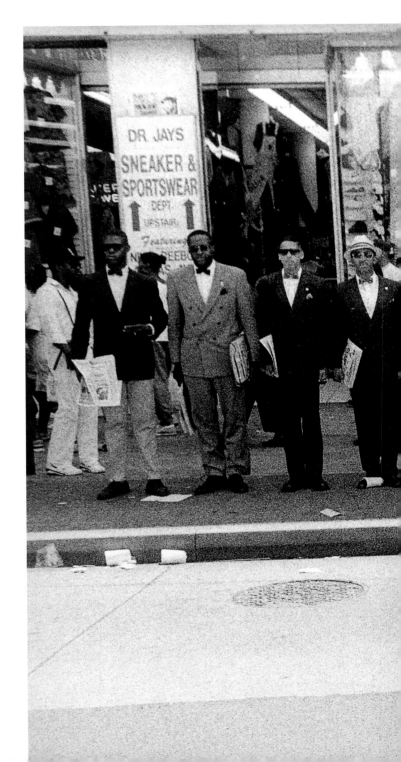

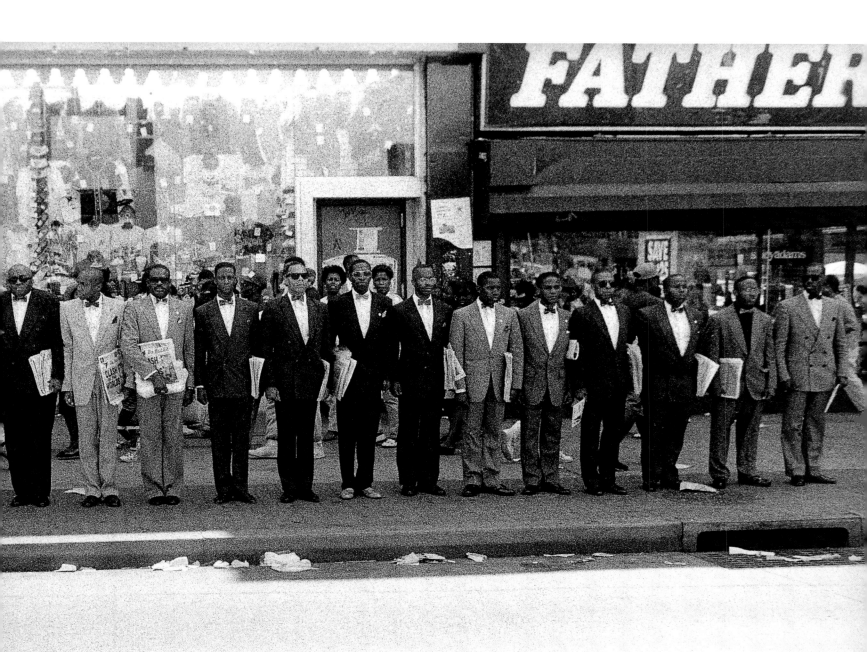

WILLIAM E. ARTIS

1914–1977

Untitled

about 1946, marble
18 x 7 ½ x 11 in.
Smithsonian
American Art
Museum, Purchase
through the Luisita L.
and Franz H.
Denghausen
Endowment

At a time when many artists were concerned with social commentary and Africanized subjects, Artis sought to reveal the universal beauty of the human form. His sensitive idealized figures and portraits of notable African Americans are positive and uplifting.

Artis usually worked in clay; this marble bust is one of his few ventures into stone carving. His idealized head of a young woman is a lively play of geometric and abstract patterns. An elongated cylinder forms her neck, while alternating triangles and ovals suggest her facial features. Delicate grooves in her head indicate an elaborate hairstyle, possibly braids. The simplified forms also reveal the artist's indebtedness to African and European art. The large ovals of her pupil-less eyes, for instance, recall ancient African sculptures, while the polished marble evokes classical Greek sculpture.

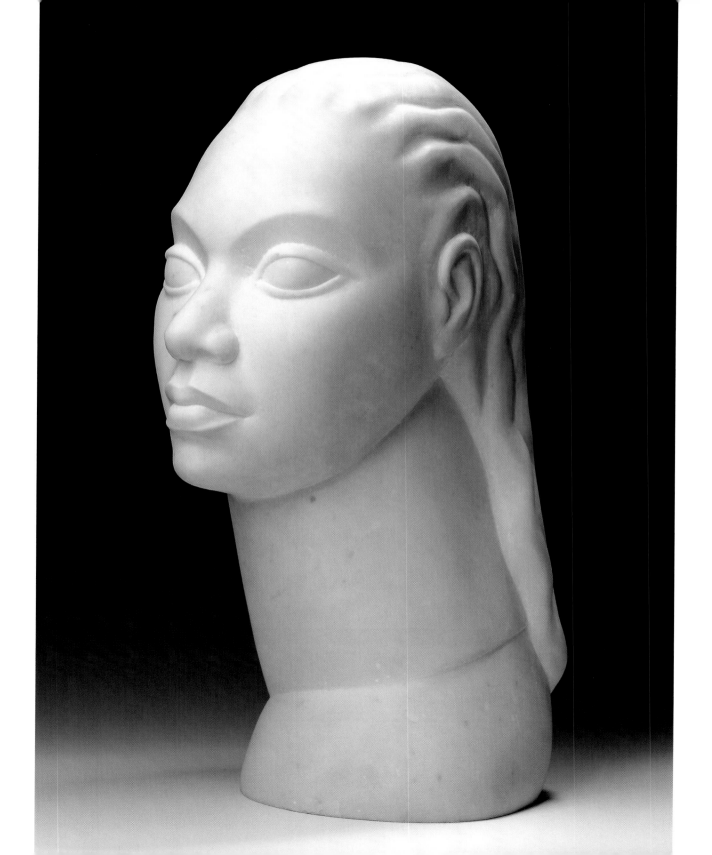

RICHMOND BARTHÉ

1901–1989

Blackberry Woman

1932, bronze
33 ¾ x 11 x 14 in.
Smithsonian
American Art
Museum, Purchase
through the
Luisita L. and Franz H.
Denghausen
Endowment

Richmond Barthé's sculptural figures were often depicted with an emphasis on movement. His *Blackberry Woman* strides purposefully forward, bearing the weight of her burden. She might be one of the market women Barthé remembered from his childhood in Mississippi, but the angularity of her body and her general pose recall the shapes of ancient Egyptian sculptures. Barthé, like many artists during the 1930s, recast African American everyday life in the enduring forms of past art.

Barthé originally modeled this work in plaster, then cast this version in bronze. Surface textures show evidence of the artist's modeling, adding visual interest as light reflects across the irregular surfaces. The graceful lines, smooth silhouette, and aloof bearing infuse this figure with the dignity of black womanhood.

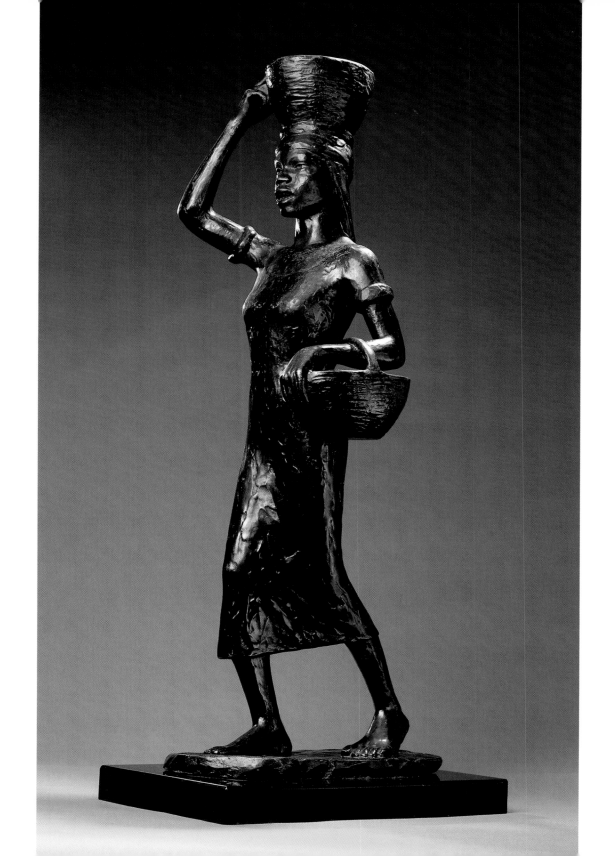

ROMARE BEARDEN

1912–1988

Empress of the Blues

1974, acrylic, pencil,
and printed paper
36 x 48 in.
Smithsonian
American Art
Museum, Purchase
in part through the
Luisita L. and Franz H.
Denghausen
Endowment

A smoky club and swaying musicians back up the mesmerizing soloist in *Empress of the Blues*. Shifting planes of colored paper and magazine cutouts create staccato patterns and rhythms, creating their own visual music. We can imagine the melody of the singer, standing with hands raised as if in rapture, and we can almost feel the pulse of the foot-stomping musicians.

Legendary singer and songwriter Bessie Smith earned the title "Empress of the Blues." She was one of the biggest stars of the 1920s and was popular with both black and white audiences. Bearden saw Smith perform in Harlem where he grew up. The statuesque Smith transfixed audiences with her fabulous voice and imposing presence. Bearden was no stranger to the transforming power of song. His love of music led him to abandon painting for two years to concentrate on songwriting, and several of his songs were published and performed.

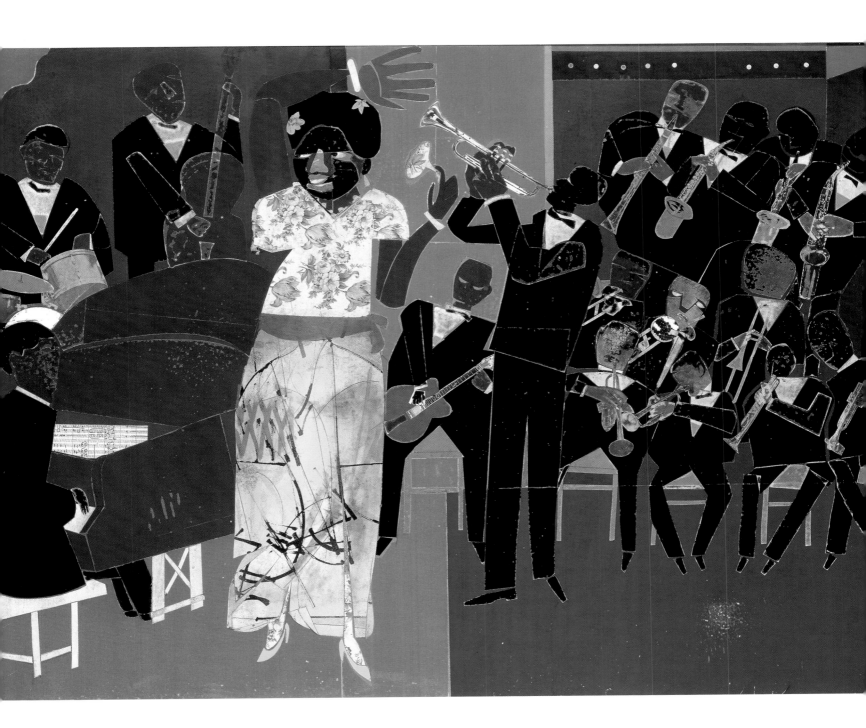

JOHN BIGGERS

1924–2001

Shotgun, Third Ward #1

1966, tempera
and oil
30 x 48 in.
Smithsonian
American Art
Museum, Purchase
made possible by
Anacostia Museum,
Smithsonian
Institution

Shotgun houses are considered an African American form of vernacular architecture. They acquired this name because, supposedly, a shotgun blast fired through the front door would pass straight through the house and out the back. Biggers, instead, suggests that the name is a corruption of the word shogon, a Yoruba term from West Africa that means "God's House."

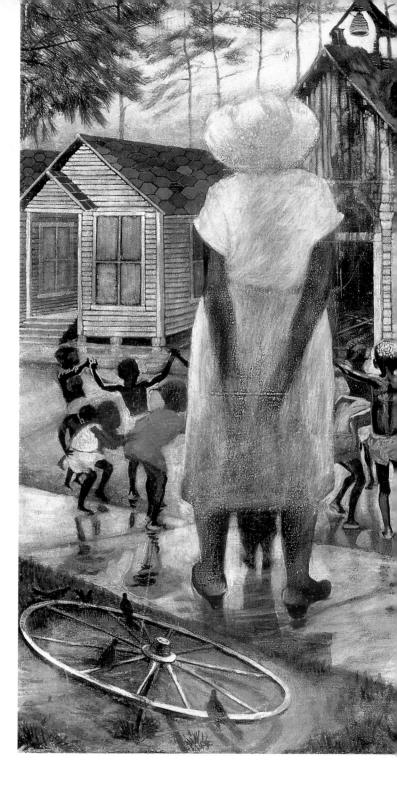

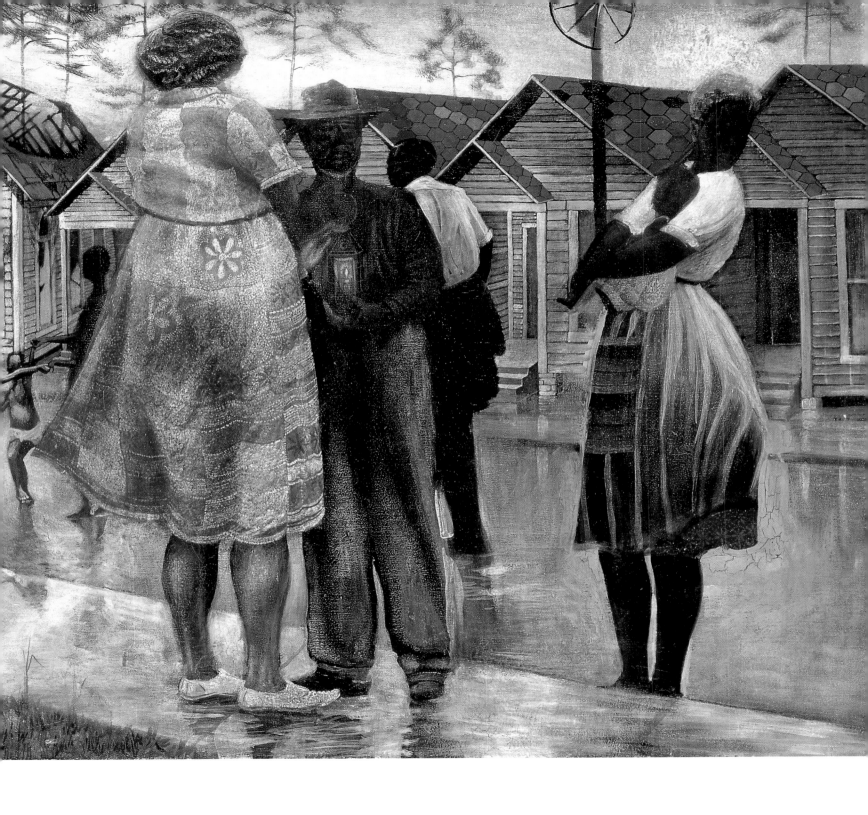

ELDZIER CORTOR

born 1916

Southern Gate

1942–43, oil
46 ¼ x 22 in.
Smithsonian
American Art
Museum,
Gift of Mr. and Mrs.
David K. Anderson,
Martha Jackson
Memorial Collection

"The Black Woman represents the Black Race. She is the Black Spirit; she conveys a feeling of eternity, and the continuum of life," according to Cortor, whose nude and semi-nude figure studies have celebrated this theme for more than sixty years. This African American woman stands unabashed, wrapped in her sensuality. She is equally unperturbed by the bird perched on her shoulder. Her confidence is all the more note-worthy against the backdrop of gathering clouds and strangely isolated gate, details that introduce a solemn moodiness.

The work's title places the scene in the South, a source of fascination for Cortor during travels throughout the Sea Islands off the coast of Georgia and South Carolina in 1940. There he encountered the black Sea Islanders, who had retained a strong sense of their African origins in their respect for nature and the practice of their religion and customs. The yearlong experience inspired a series of paintings about the South, here portrayed as a mildly decadent landscape that recedes in the presence of the beauty and dignity that Cortor associates with women as the archetype of African American culture.

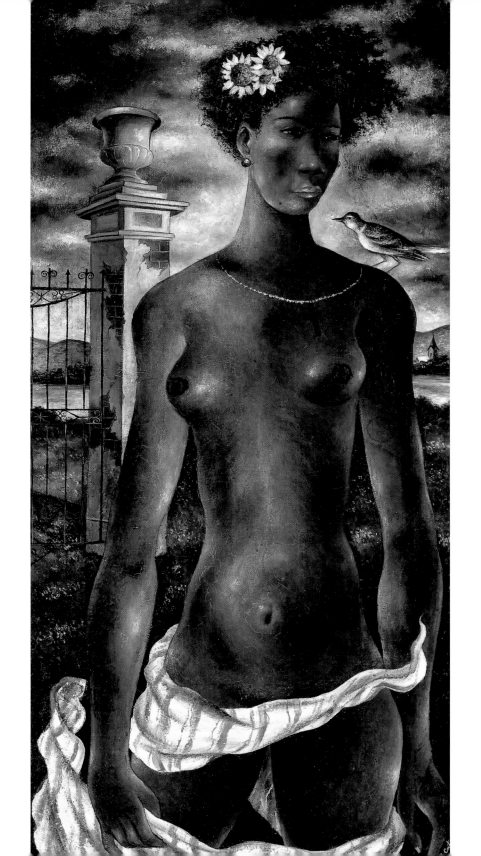

ALLAN ROHAN CRITE

born 1910

Sunlight and
Shadow

1941, oil on board
25 ¼ x 39 in.
Smithsonian
American
Art Museum,
Museum purchase

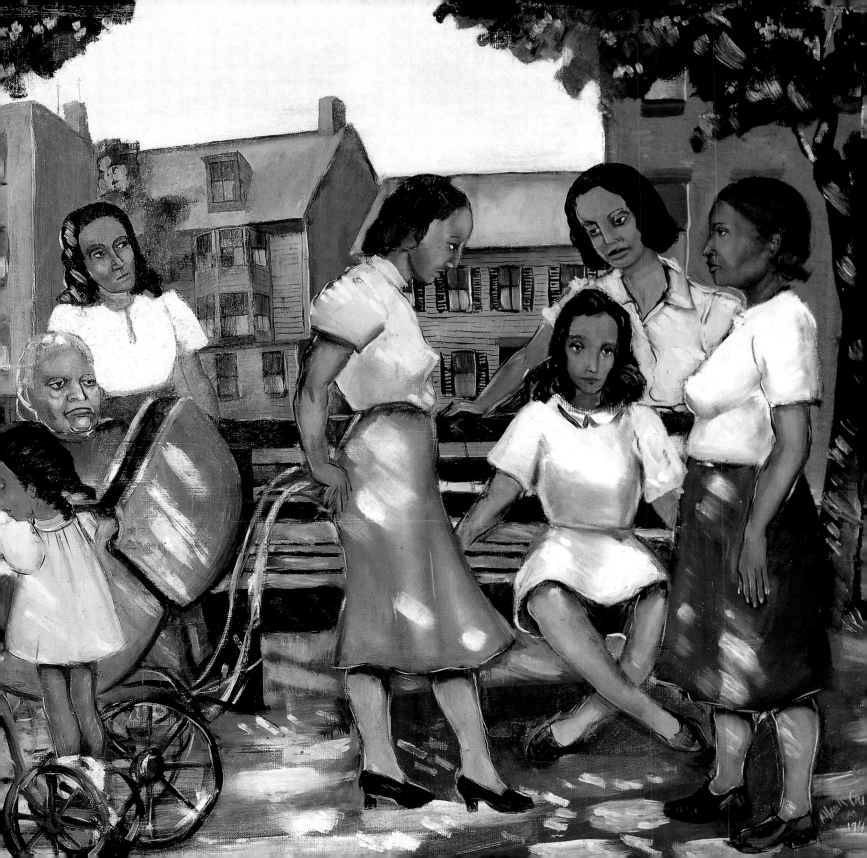

ROY DeCARAVA

born 1919

Couple Dancing, New York

1956/printed 1982
gelatin silver print
14 x 10 7/8 in.
Smithsonian
American Art
Museum, Purchase
made possible by
Henry L. Milmore

Couple Dancing, New York demonstrates the dramatic lighting and sensuous tonalities that earned Roy DeCarava the title "poet of light." Using a small hand-held camera, he has always relied upon available light, even in dim and cramped interiors. DeCarava strips away nonessential elements, allowing the viewer to focus on light, shadow, and gesture. Rich blacks form the background from which the shadowy figures emerge. Whites and grays anchor them figuratively and pictorially, preventing the figures from dissolving into the dense mysterious background. Referring to his affinity for tone over sharp contrast, DeCarava has said that he relies upon "the infinite gradations of black and white." Subtle reflections off the woman's bare arm, earring, and dress hem convey the measured steps of their dance. Though faceless and anonymous, the couple's intimate bond comes across clearly through DeCarava's masterful evocation of touch and tone.

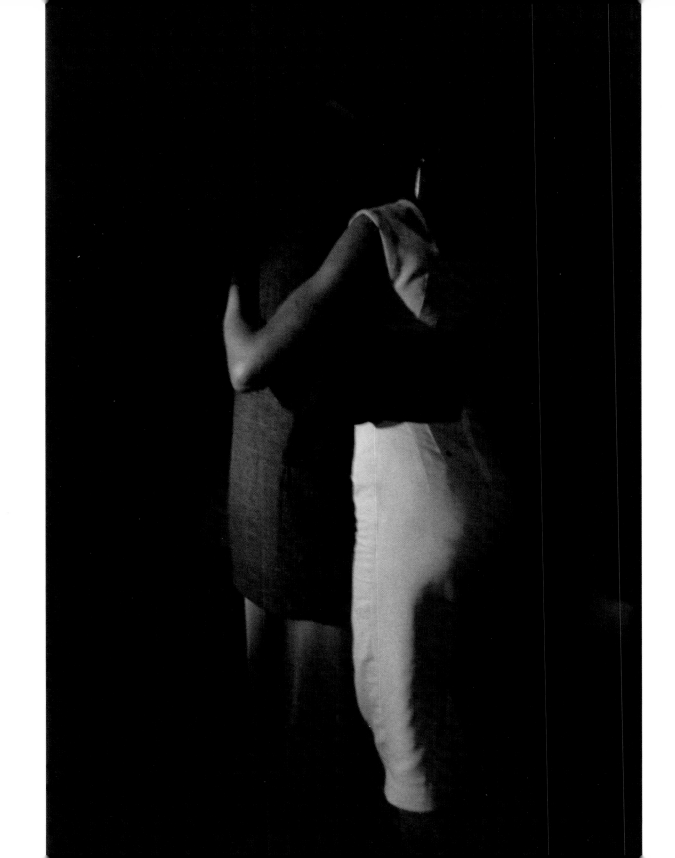

ROY DeCARAVA

born 1919

Graduation, New York

1949/printed 1982
gelatin silver print
10 ⅞ x 13 ⅞ in.
Smithsonian
American Art
Museum, Purchase
made possible by
Henry L. Milmore

Graduation, New York is one of 140 photographs published in *The sweet flypaper of life,* a collaborative endeavor that teamed photographer DeCarava with poet and novelist Langston Hughes. The publication was a commercial and critical success. Hughes's fictional account of life seen through the eyes of Sister Mary Bradley gives us a character whose commentary reflects social and historical changes in Harlem.

BEAUFORD DELANEY

1901 USA–1979 France

Can Fire in the Park

1946, oil
24 x 30 in.
Smithsonian
American
Art Museum,
Museum purchase

Flames roar from the wire-mesh trashcan, warming several men who brace themselves against the cold. Delaney's bright colors and swirling brushwork add a visual heat and energy to the scene. Strategically placed arrows and circles, mimicking street signs, anchor the composition and enliven the somber subject. Repetitive verticals—the streetlights, trees, and erect posture of the figures—lend nobility to these people forced to find warmth in a city park.

Born in Tennessee, Beauford Delaney lived in New York's Harlem and Greenwich Village in the 1930s and 1940s, when the Harlem Renaissance was in full bloom. Beauford lived an uncertain life as an artist and was in constant need of funds to continue his work and studies. Painted in 1946 as America was emerging from years of war and the Depression, Delaney's picture focuses on the neediest of the urban poor.

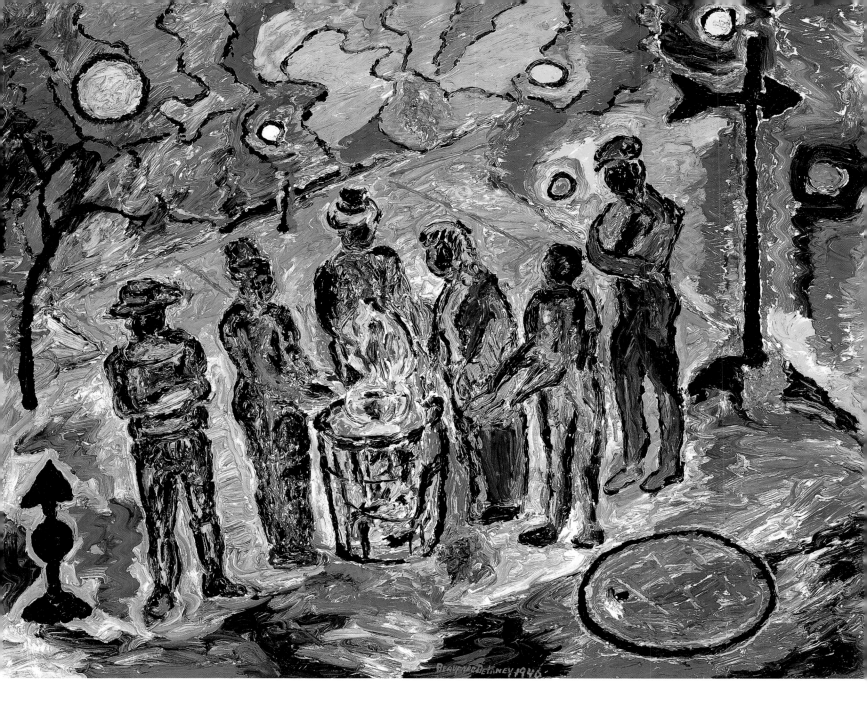

JOSEPH DELANEY

1904–1991

Penn Station at War Time

1943, oil
34 x 48 ¼ in.
Smithsonian
American Art
Museum, Gift of
Joseph Delaney

Joseph Delaney painted this crowd scene at New York's Penn Station two years after the United States entered World War II. Joseph, like his older brother and fellow painter Beauford, had moved from Tennessee to New York during the Depression. Throughout his career, his favorite and best-known subjects were the expressive crowd scenes of New Yorkers engaged in daily activities.

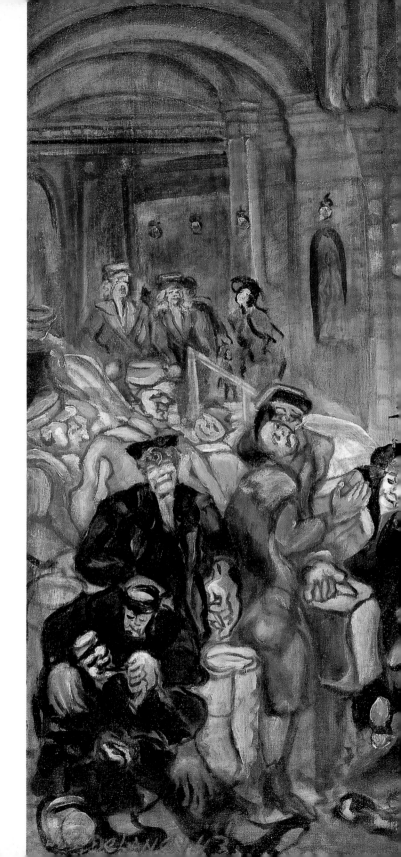

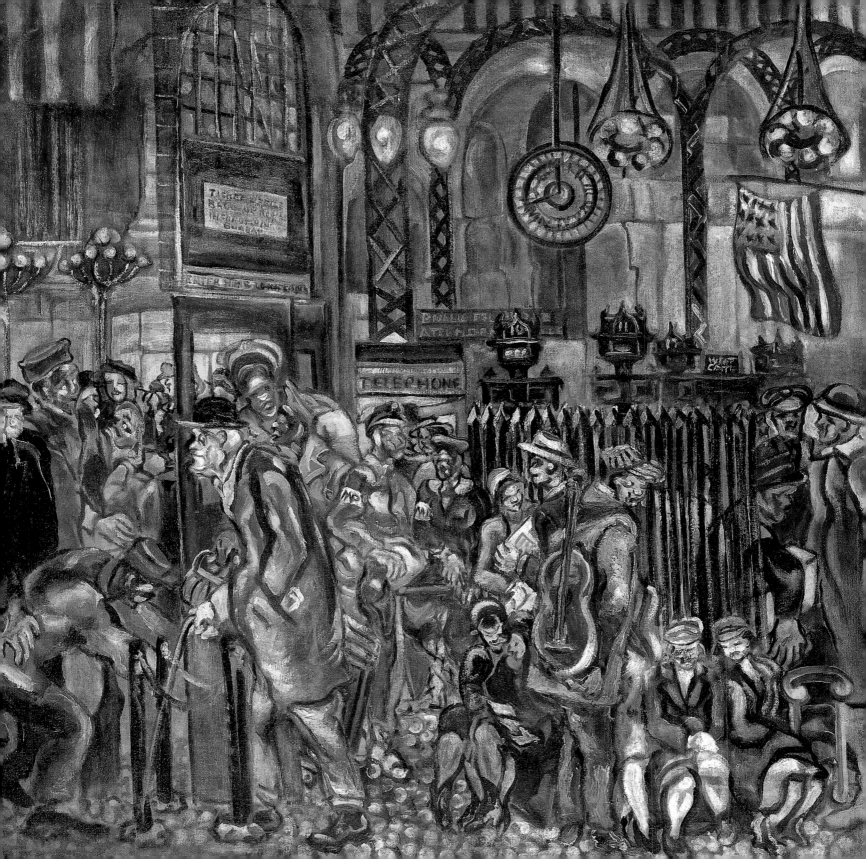

THORNTON DIAL SR.

born 1928

Top of the Line (Steel)

1992, enamel,
roping, and found
metal objects
65 x 80 ⅞ x 7 ⅞ in.
Smithsonian
American Art
Museum, Gift from
the collection of
Ron and June Shelp

From this swirling mass of wood, metal, and rope emerge anguished faces. Most stare directly at the viewer with wide eyes and opened mouths. One face, however, hangs listlessly to the side. As we follow the ocher outline of its torso and dangling limbs, the eerie figure resembles a lynched body. Dial's reference to violence was not coincidental. The artist created this work after the riots in Los Angeles in the summer of 1992. Thousands looted businesses and damaged property in response to the verdict acquitting white police officers, who had been videotaped brutally beating an unarmed black motorist. Dial, a former steelworker, uses refrigerator, air conditioner, and automobile parts to refer to goods coveted by looters. His title, *Top of the Line*, not only describes the products, but also alludes to popular advertising slogans for high-end appliances and automobiles. The subtitle, "Steel," is a satirical reference to looting as well as an indication of the metal scraps and debris used to fabricate this work.

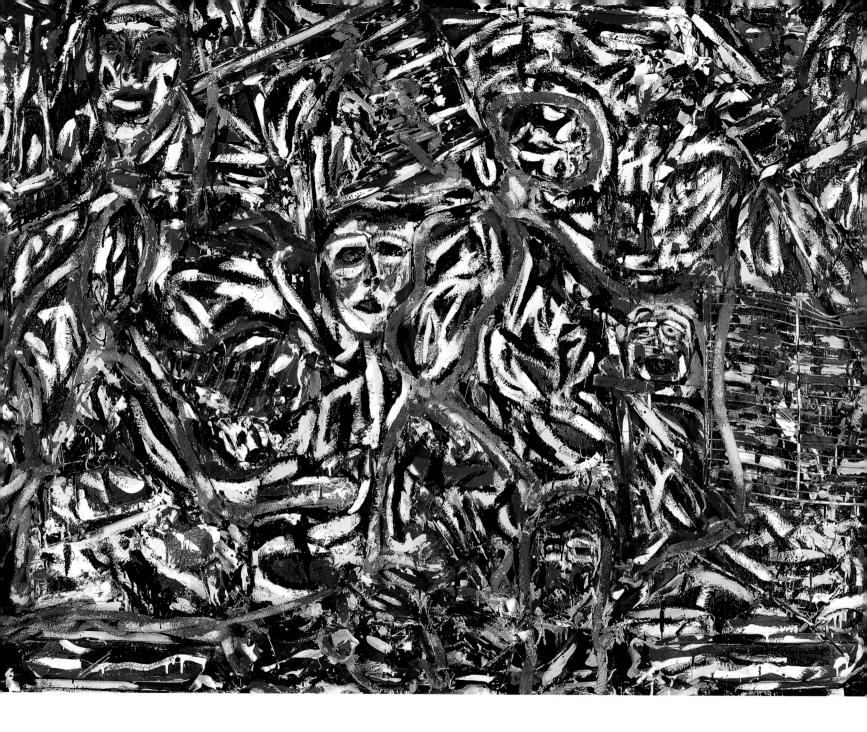

MELVIN EDWARDS
born 1937

Tambo

1993, welded steel
28 1/8 x 25 1/4 x 22 in.
Smithsonian
American Art
Museum, Purchase
through the
Luisita L. and Franz H.
Denghausen
Endowment
and the
Smithsonian
Institution
Collections
Acquisition Program

Tambo is a startling assemblage of tools and farm implements. A spear and shovel share space in a narrow cup. Two iron rods, the type used in soldering, an adjustable wrench, and a regular wrench form the contents of another cup. A portion of an I-beam and a chain attached to a tire iron complete this unusual grouping. Although many of these items suggest trade and commerce, the spear connotes preindustrial Africa. Most of the components are actual utilitarian objects, but others, such as the spear, have been fashioned from another object. This mix of literalness and symbolism is typical of Mel Edwards's sculptures.

The date and title of this "steel life" are significant. Edwards frequently names his sculptures after African words and people. This work pays particular homage to Oliver Tambo who died in 1993. Tambo, a South African activist, co-founded with Nelson Mandela the Youth League of the African National Congress (ANC) in 1944.

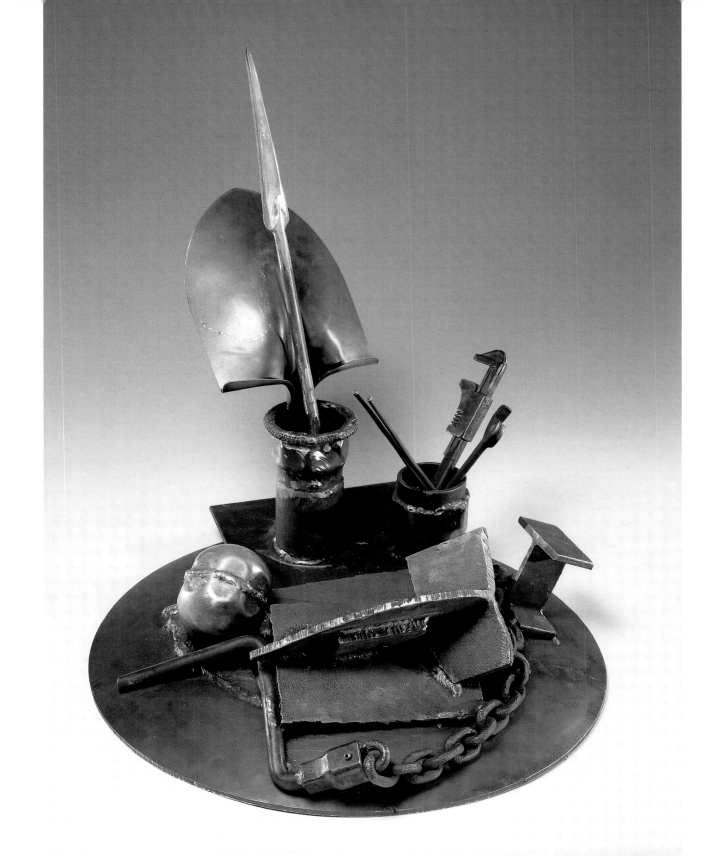

ROLAND L. FREEMAN

born 1936

Bikers take a break. Sunday afternoon in Druid Hill Park, Baltimore, Maryland, September 1973

from the series *Southern Roads/City Pavements*

1973/printed 1982
gelatin silver print
11 1/8 x 13 7/8 in.
Smithsonian
American Art
Museum, Gift of
George H.
Dalsheimer

Roland Freeman suggests through pose and gesture the carefree rapport among friends. The young man at the left exhales a trail of cigarette smoke, while looking directly at the camera. His nearest companion gazes at him in admiration. Another styles his large Afro, and the fourth smiles as something outside the picture's frame captures his attention. Their bent elbows and raised arms subtly guide the viewer's eye across the composition.

The artist's understanding of the easy camaraderie among these friends comes from first-hand knowledge. Born in Baltimore, between 1971 and 1973 Freeman rarely missed a Sunday afternoon in Druid Hill Park, a popular Baltimore destination where families and friends met and mingled. Freeman's interest in photography was spurred by the Civil Rights Movement of the 1960s. For nearly thirty years, he has chronicled the experiences and traditions in his community.

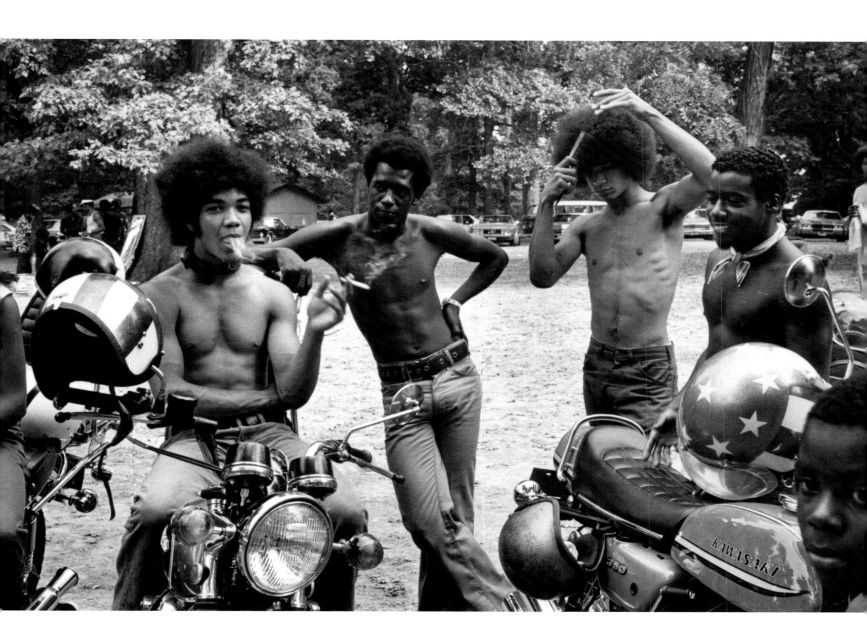

SAM GILLIAM

born 1933

Open Cylinder

1979, oil
81 x 35 ½ in.
Smithsonian
American Art
Museum, Gift of
Mr. and Mrs. Albert
Ritzenberg

Open Cylinder is composed of geometric shapes that appear to float and shift across a painted surface. In the center, orange lozenges create the illusion of gliding across the divide that separates the diptych. Deep scratches in the thick paint heighten the sense of movement. These thrusting verticals, covered with rectangles and arched forms, suggest a pillar that has been shattered, its shards now resting side-by-side.

Gilliam is an innovative color field painter who has advanced the inventions associated with the Washington Color School. During the late 1970s, Sam Gilliam discovered that by cutting and rearranging geometric shapes from thickly painted canvases, he could expand his experiments in color and improvisation. The shifting irregular patterns in these randomly patterned canvases resemble those found in African American "crazy quilts." His large-scale installations in metro stations and airports are as stimulating as his studio pieces.

The Janitor Who Paints

about 1937, oil
39 1/8 x 32 7/8 in.
Smithsonian
American Art
Museum, Gift of the
Harmon Foundation

At first glance, this portrayal of an artist at work appears fairly conventional. The painter, surrounded by his palette, brushes, and easel and wearing a beret, seems confident and self-assured. His subject—a mother and child—is a time-honored theme in art. In fact, little seems out of place here until one looks closer. The artist's studio is actually a bedroom, furnished with bed, nightstand, and alarm clock. Signs of the artist's other job, a broom and feather duster, are neatly placed against the wall.

A scene such as this was familiar to Hayden, who took odd jobs and custodial work while pursuing his artistic career. He maintained, however, that it pays homage to a friend and fellow painter, Cloyde Boykin, who was never recognized "because no one called him a painter; they called him a janitor." Hayden received classical art training in New York, Maine, and Paris, but created a personal style that resembles the simplified forms of early American folk art.

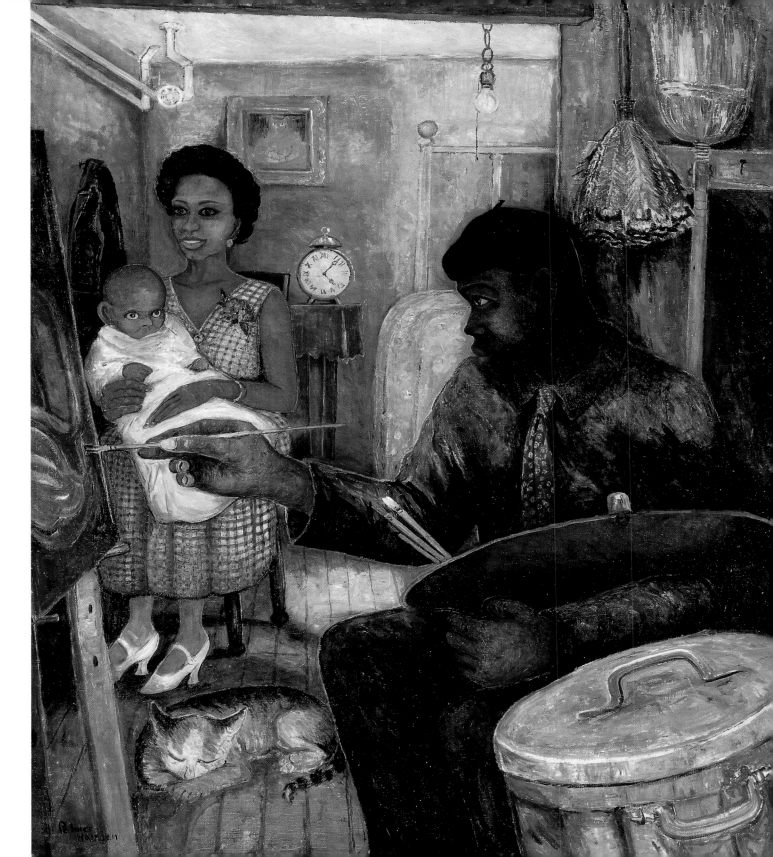

FELRATH HINES

1913–1993

Yellow and Gray

1976, oil on linen
54 ¼ x 48 in.
Smithsonian
American Art
Museum, Gift of the
Barbara Fiedler
Gallery

These colored circles and elongated forms could be read as an abstract still life, depicting sliced lemon, knife, banana, and pewter tankard. Felrath Hines, however, was more interested in the dialogue between color and form than in direct representation. By placing the yellow half circles in front of a horizontal gray band, the artist reveals how subtle hue changes occur. The same changes occur in the background, as the gray on the left appears lighter than that on the right when separated by yellow.

Hines was an early and prominent member of Spiral, an association of African American artists founded in New York in the 1960s in response to the Civil Rights Movement. His later geometric abstractions embrace the universal language of pure shapes and colors. In 1983 he said, "In my view, an artist's work is to rearrange everyday phenomena so as to enlarge our perception of who we are and what goes on about us."

EARLIE HUDNALL JR.

born 1946

Looking Out

1991

gelatin silver print

19 ⅞ x 16 in.

Smithsonian

American

Art Museum,

Museum purchase

This youngster's stare is so direct that he seems to look at and through us, a glance that suggests he is wiser than his age. Completely at ease in his surroundings, he grips the wooden frame as if our presence has temporarily halted him in mid-motion. In fact, his right elbow and knee extend past the frame, entering our space. His posture, dress, and expression appear spontaneous, but the image is carefully composed. The figure fills the foreground, but sidewalks and paths behind him lead us past and into the composition. The wooden frame, his raised arms, and walkways create repetitive lines and patterns that enliven the composition.

Born in Hattiesburg, Mississippi, Earlie Hudnall Jr. has lived for years in Houston, Texas. He began photographing while in the U.S. Marine Corps in the 1960s and finds inspiration in the beauty and pride in everyday life in African American communities in the South.

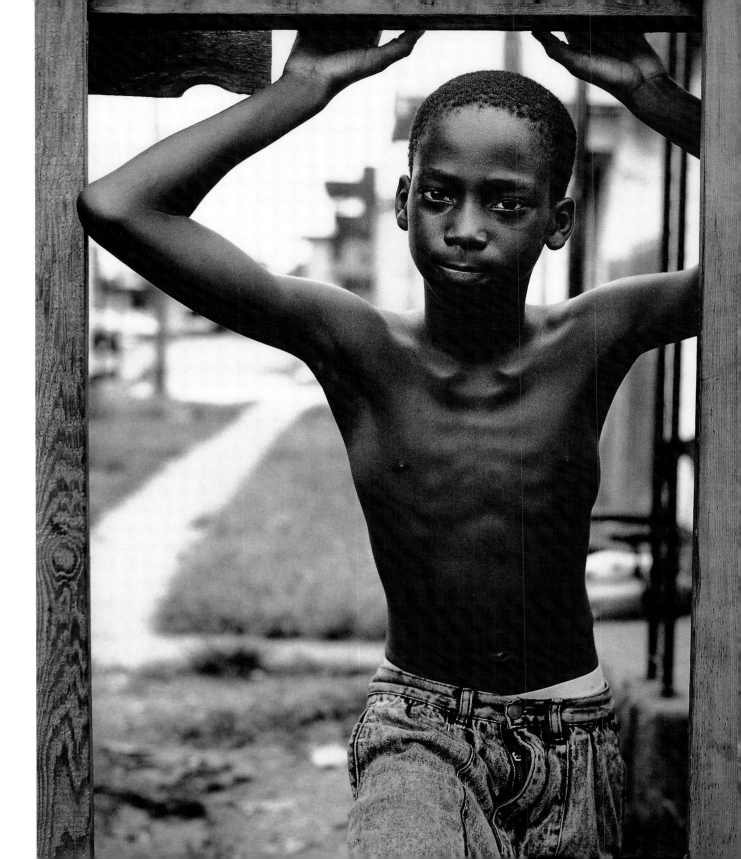

MALVIN GRAY JOHNSON

1896–1934

Brothers

1934, oil
38 x 30 ⅛ in.
Smithsonian
American Art
Museum, Gift of the
Harmon Foundation

Two young boys sitting shoulder-to-shoulder vie for space on a wooden bench. Their denim overalls and white shirts are almost identical, but one wears a straw hat and the other a bib cap. The youngster on the left, possibly the older, occupies more of the bench to face the viewer with a direct and confident gaze. His younger companion, forced to sit on the edge, appears brooding.

With proceeds from his employment with the Public Works of Art Project, Malvin Gray Johnson was able to realize his goal of traveling to rural Virginia. It was during this visit that he made numerous studies in a modern folk style of its agrarian African American community, including this casual scene of jousting brothers. The gift of this painting was a part of the dispersal of Johnson works by the Harmon Foundation, an organization cited among the earliest efforts to recognize the achievements of African Americans and promote the work of visual artists.

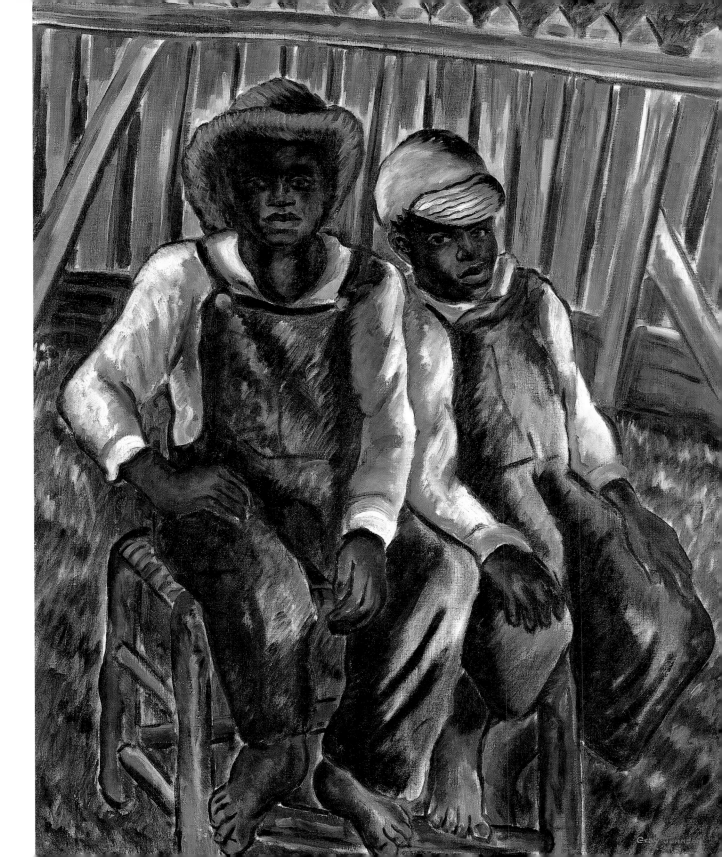

SARGENT JOHNSON

1887–1967

Mask

about 1930–35
copper on wood base
15 ½ x 13 ½ x 6 in.
Smithsonian
American Art
Museum, Gift of
International
Business Machines
Corporation

Painted copper and wood form a bust-length figure of a young woman wearing a ringed necklace or collar. Her elaborately braided hair lies flat against her head. Raised contours define her mouth, eyes, and eyebrows. The smoothly polished, rounded surfaces of the triple-tiered wood base echo the streamlined, elegant lines. Her erect bearing suggests nobility and refinement.

During the 1930s, Sargent Johnson executed several copper masks and sculptures based on African examples. Johnson explained his intent saying: "It is the pure American Negro I am concerned with, aiming to show the natural beauty and dignity in that characteristic lip and that characteristic hair, bearing, and manner; and I wish to show that beauty not so much to the White man as to the Negro himself." His work beginning in the late 1940s would shift from African subjects to the heavy influence of his travels to archaeological sites in Mexico.

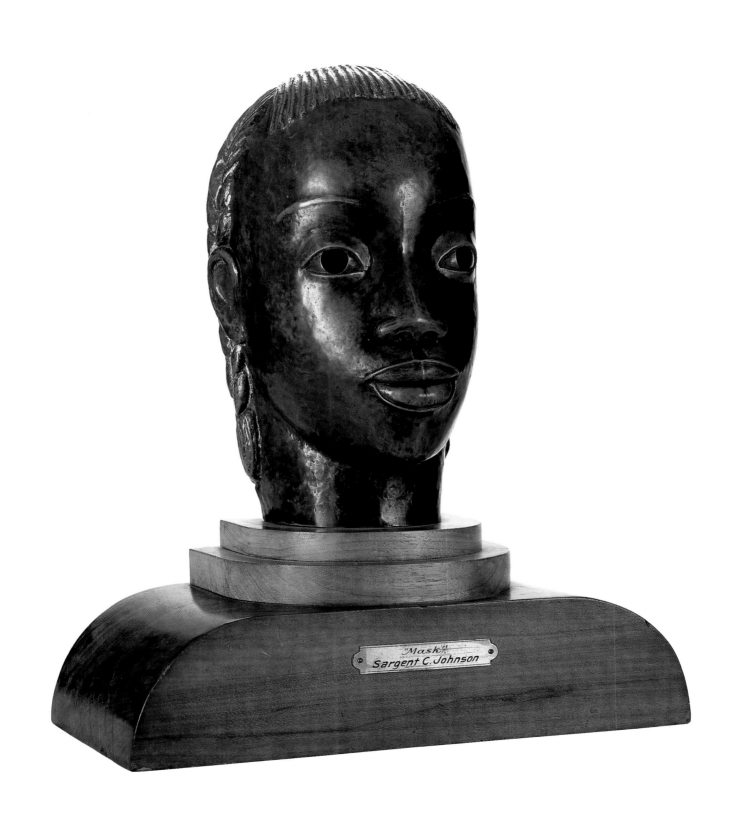

"Mask"
Sargent C. Johnson

WILLIAM H. JOHNSON

1901–1970

Going to Church

about 1940–41

oil on burlap

38 1/8 x 45 1/2 in.

Smithsonian

American Art

Museum, Gift of the

Harmon Foundation

An African American family in their mule-drawn wagon travels the road between the two mainstays of their life—hard work on the farm pictured to the right and spiritual support from the church seen at the left. Sunday as the day of rest envelopes the scene, from the family's sober attire to the composition's striking sense of balance. "All's right with the world" as horizontals and verticals counter each other, motifs like trees, wheels, adults, children, and buildings appear in pairs, and unexpected color combinations harmonize.

Survival through faith and family is the clear message from an artist who wanted "to express in a natural way what I feel, what is in me, both rhythmically and spiritually, all that which in time has been saved up in my family of primitiveness and tradition." Johnson's childhood in rural South Carolina provided a deep wellspring of imagery as he began painting the history, folklore, and spirit of the African American experience in 1938, when he returned to the United States after more than a decade of study and work as an expatriate in Europe.

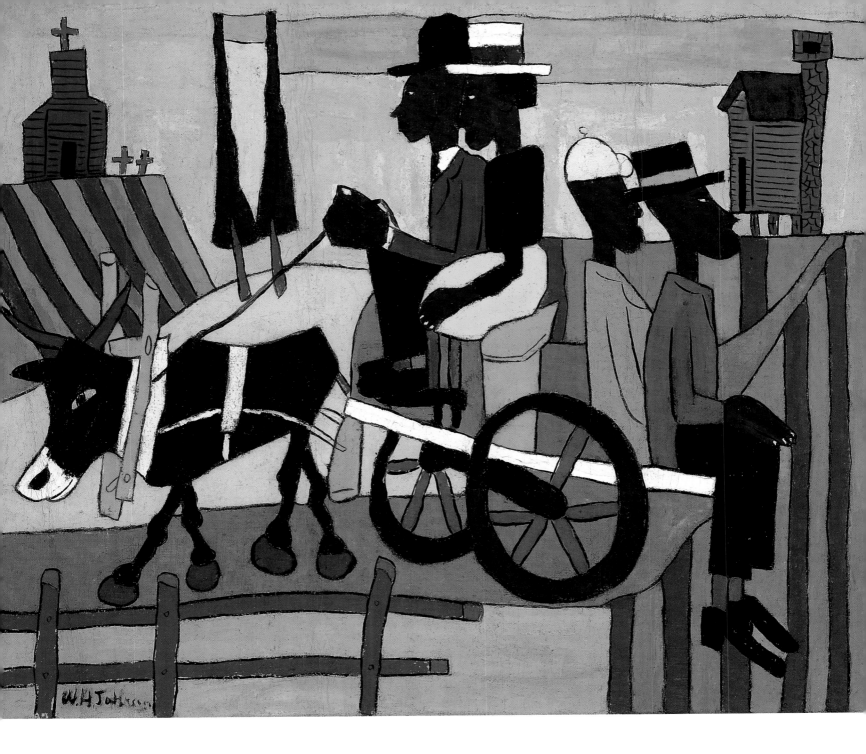

WILLIAM H. JOHNSON

1901–1970

Midnight Sun, Lofoten

1937, oil on burlap
41 ⅝ x 59 ⅛ in.
Smithsonian
American Art
Museum, Gift of the
Harmon Foundation

Johnson painted this scene on a summer trip to Norway, famed "land of the midnight sun." Every day for a month he climbed the mountain peaks, which rise 2,000 feet above the sea, to capture this view. Using bold brushstrokes, the artist evokes the exotic lighting of the suspended midnight sun in a red-orange sky reflecting off the blue-green mountain peaks.

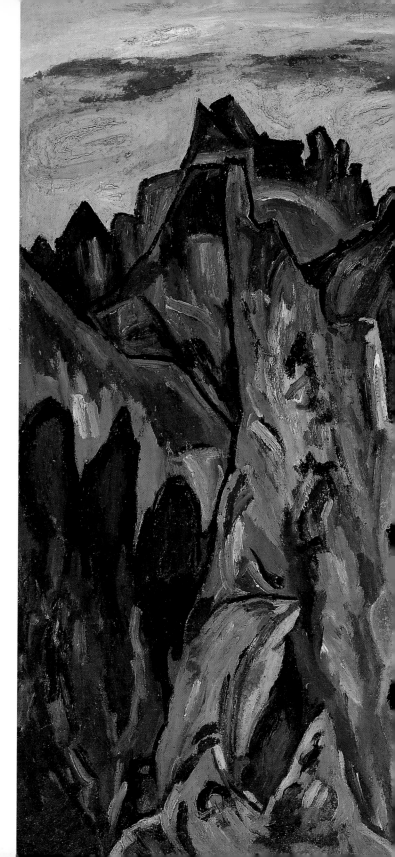

WILLIAM H. JOHNSON

1901–1970

Street Life, Harlem

about 1939–40

oil on plywood

45 ¾ x 38 ⅝ in.

Smithsonian
American Art
Museum, Gift of the
Harmon Foundation

Street Life, Harlem celebrates the people and dynamic energy of Harlem in the late 1930s. This couple, standing on a street corner, is poised for an evening on the town. The young woman adjusts her elbow-length gloves as her companion checks his pockets. Even the multicolored buildings surrounding them and the sidewalk beneath them throb and pulsate with life. Amusingly, the lettered signs allude to their range of nighttime activities. The Lindy Hop was being danced in popular Harlem night spots, and rent parties with lively music and dance were held by residents to raise funds to meet the rent. Johnson had many opportunities to experience this night life during the four years he taught art at the Harlem Community Art Center. These were vibrant years in Harlem, when positive portrayals of everyday life strengthened the sense of community that was such an important aspect of African American culture.

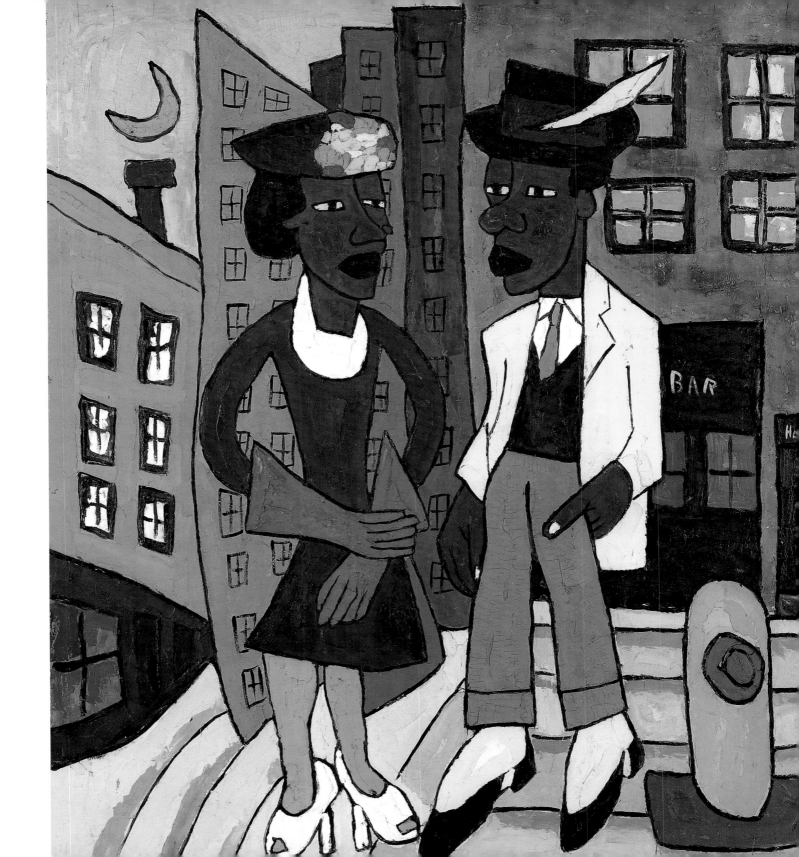

WILLIAM H. JOHNSON

1901–1970

Village Houses, Cagnes-sur-Mer

about 1928–29, oil
31 x 25 ⅛ in.
Smithsonian
American Art
Museum, Gift of the
Harmon Foundation

Buildings that seem to gyrate fill William H. Johnson's frenetic, restless scene. The cockeyed structures weave and bob along the narrow street, amplifying the jaunty gestures of the busy townspeople as they scurry about their business. Located on the French Riviera, the coastal village of Cagnes was a popular tourist spot that attracted many artists, including Johnson, because of its informality, inexpensive accommodations, and brilliant light.

While in France Johnson worked in a range of styles, influenced by a number of European artists but particularly by Paul Gauguin. Cagnes and impressionism weren't the only influences on Johnson at this time; he met his future wife, the textile artist Holcha Krake, in Cagnes. The tipsiness of the scene may well have been inspired by the intoxicating introduction of romance.

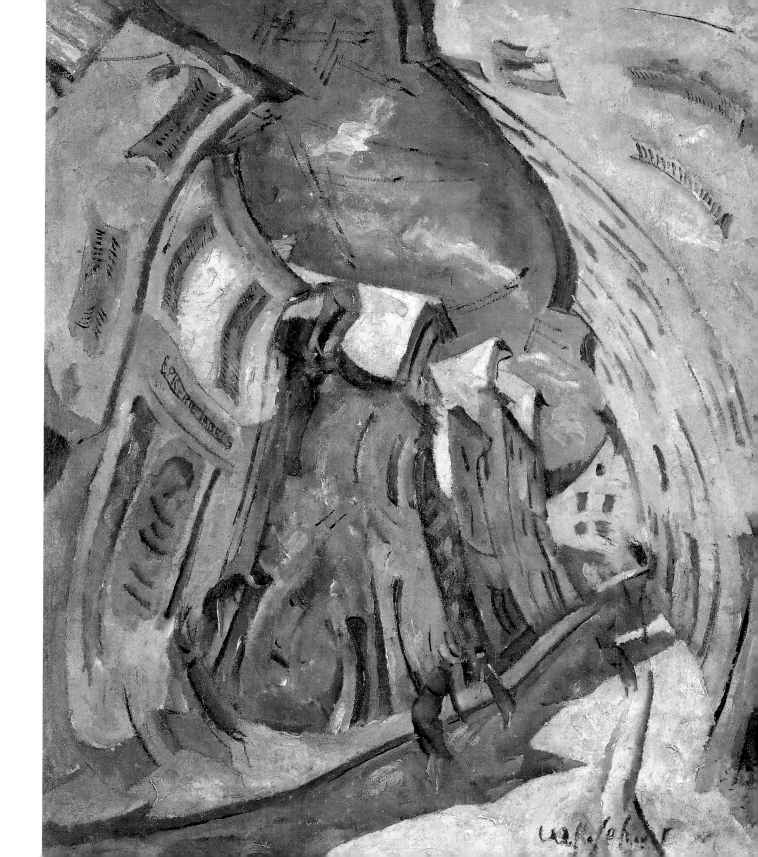

LOIS MAILOU JONES

1905–1998

Les Fétiches

1938, oil on linen
21 x 25 ½ in.
Smithsonian
American Art
Museum, Purchase
made possible by
Mrs. N. H. Green,
Dr. R. Harlan, and
Francis Musgrave

Fetishes are inanimate objects endowed with magical powers. These masks, standing red figure, and small white amulet quiver and dance mysteriously against a darkened backdrop. Lois Mailou Jones, however, seems less interested in their ceremonial, ritualistic use than in their overlapping shapes and geometric patterns, which enliven her ingenious composition. Jones distills qualities found in various mask materials—wood, raffia, horn, and metal—and selects colors that allude to but do not imitate actual objects.

Jones continued to develop her own style of painting throughout her career. She moved increasingly away from landscapes and colorful street scenes and began to create works that were influenced by her African American heritage. Her interest in African art had developed while she was in her teens. It wasn't until 1938, however, while on her sabbatical year in Paris, that Jones created this work, her first to use African art as its primary theme.

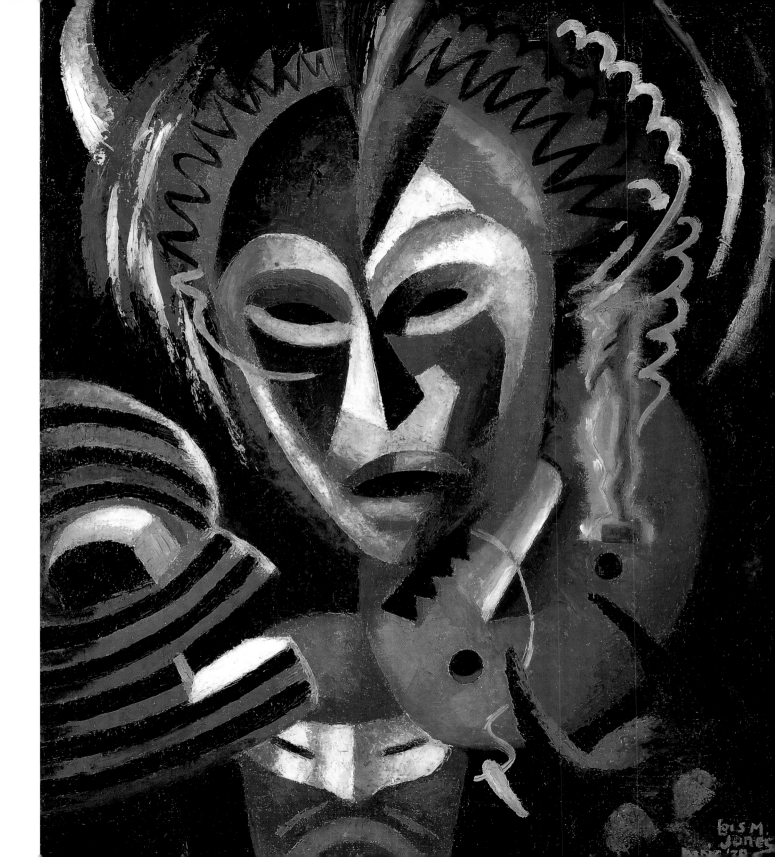

JACOB LAWRENCE

1917–2000

Firewood #55

1942, gouache,
ink, and watercolor
22 ¾ x 31 in.
Smithsonian
American Art
Museum, Transfer
from the U.S.
Information Agency
through the
General Services
Administration

Jacob Lawrence created *Firewood* on his first visit to the rural South, capturing farm life during a Depression-era winter. The subdued palette and abstract patterns convey the family's grim condition. Nothing grows in the barren landscape, yet family chores must continue. Clothes hang out to dry and wood is gathered to heat the home and provide fuel to do laundry and preserve meats. The center building, with its smoking chimney, could be the smokehouse, and the building on the left probably served as the family's home. It resembles the traditional shotgun house; we can even see through its opened doors. The third structure, slightly away from the group, may be the outhouse.

New Jersey-born Lawrence spent his teen and early adult years in New York's Harlem neighborhood. In 1941 he traveled to the South on a fellowship to depict life in a rural community. Throughout his prolific sixty-year career as an artist, teacher, and writer, Lawrence addressed the African American experience and mankind's struggle for social justice with his signature style.

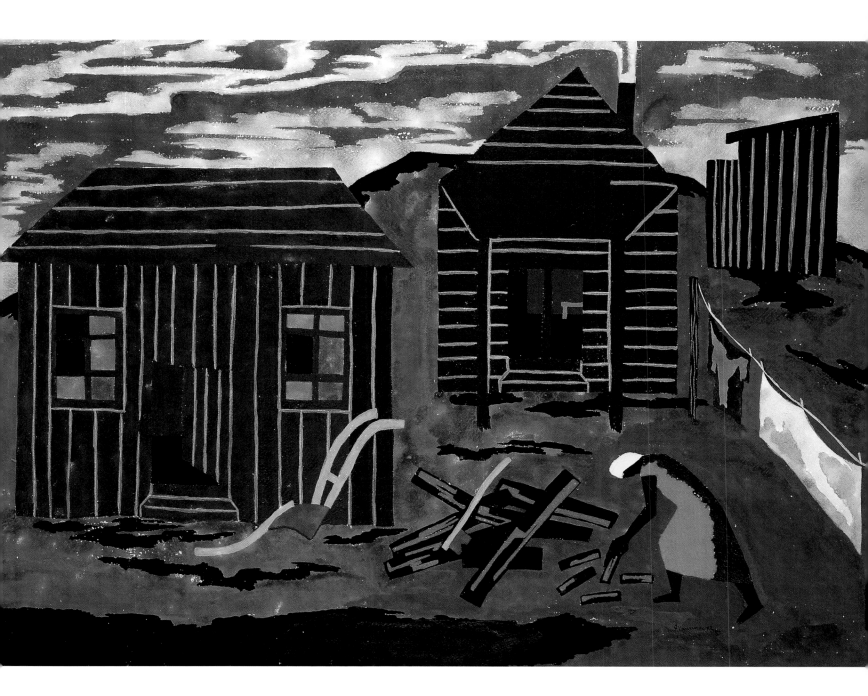

JACOB LAWRENCE

1917–2000

The Library

1960, tempera on
fiberboard
24 x 29 ⅞ in.
Smithsonian
American Art
Museum, Gift of
S. C. Johnson &
Son, Inc.

Fourteen figures are present in this cordial and inviting library. Warm ochers and browns suggest tables, chairs, and flooring, while purple, red, green, gold, and black enliven the readers and the books that captivate them. Situated in Lawrence's flattened space, the angular figures in the foreground create a horizontal emphasis, connecting the middle and background filled with readers at tables with tops tipped upward. The reduced scale of the figures toward the top of the painting suggests depth in what is basically a two-dimensional space.

Jacob Lawrence's view of a library filled with readers recalls his childhood experiences when he frequently visited the 135th Street Public Library in Harlem. This institution was the site of lectures on African and African American history and was home to the largest accumulation of black studies materials in the world—a treasury of resources that contributed to a new black consciousness, helping to inspire the Civil Rights movement.

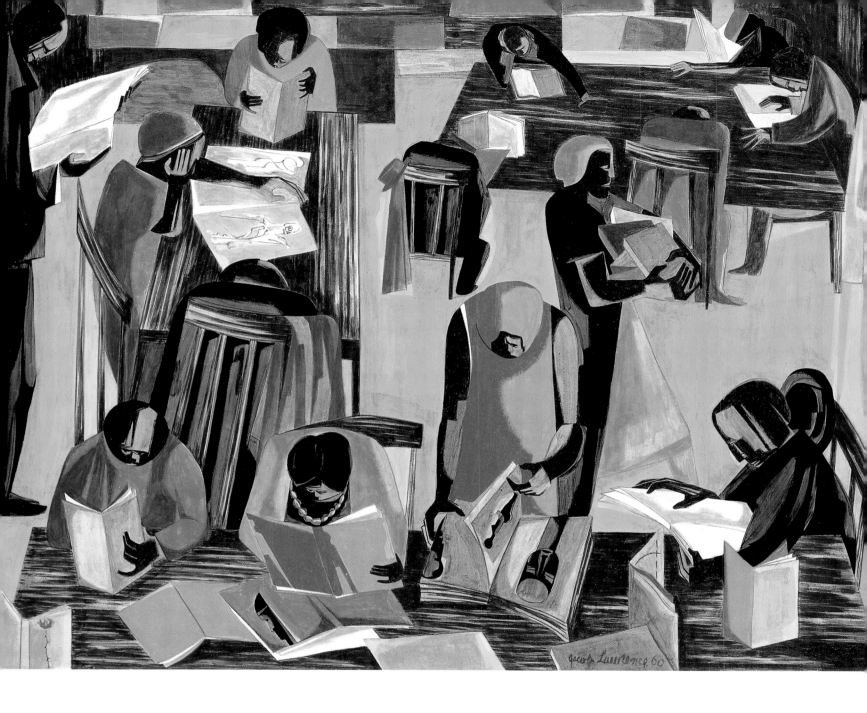

HUGHIE LEE-SMITH

1915–1999

The Stranger

about 1957–58, oil
26 ¼ x 36 ⅛ in.
Smithsonian
American Art
Museum,
Museum purchase

When Hughie Lee-Smith saw this painting thirty years after painting it, he re-named it *The Stranger* because he was struck by the figure's separation from the town. "In my case, aloneness . . . has stemmed from the fact that I'm black. Unconsciously it has a lot to do with a sense of alienation."

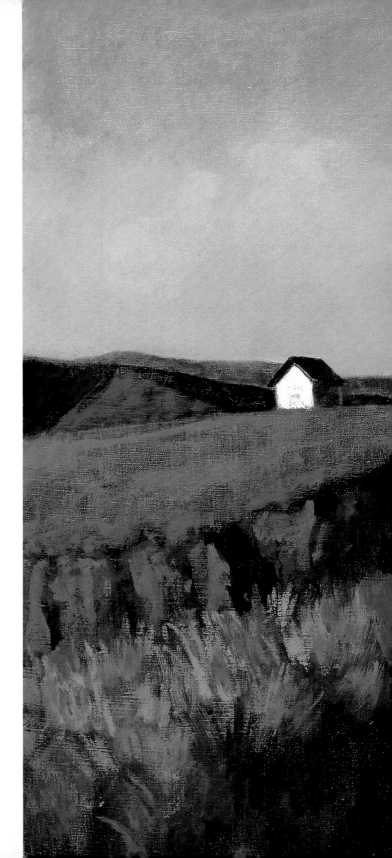

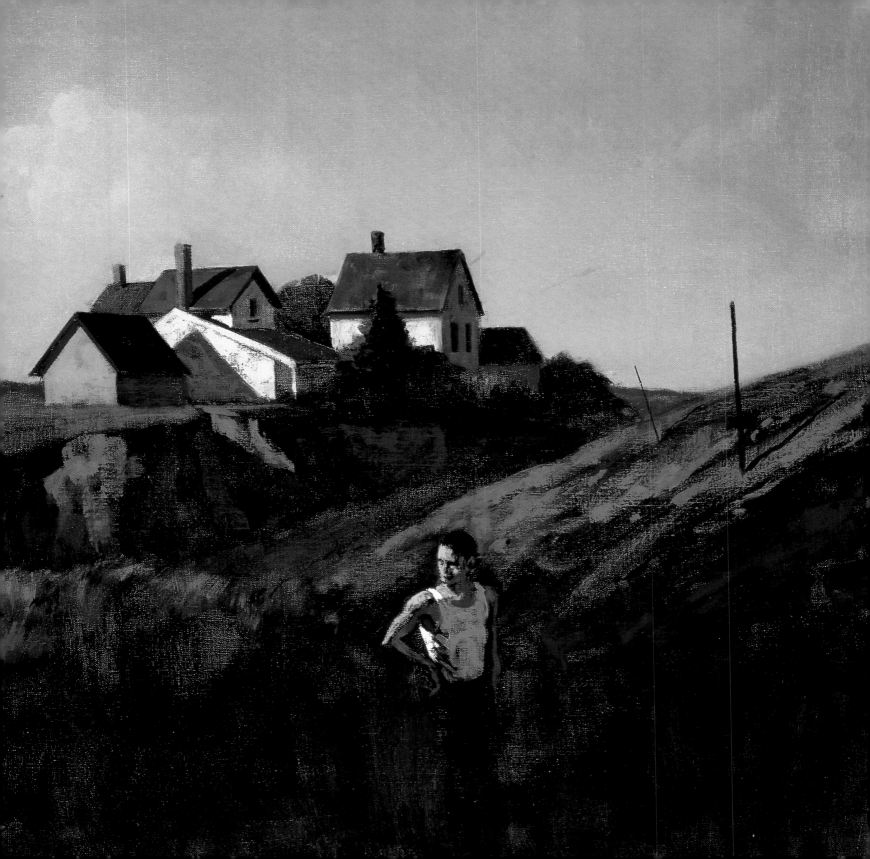

NORMAN LEWIS

1909–1979

Evening Rendezvous

1962, oil on linen
50 ¼ x 64 ¼ in.
Smithsonian
American
Art Museum,
Museum purchase

Evening Rendezvous conjures up ethereal forms floating through a misty landscape. Their vaporous colors and the lyrical patterns they weave seduce us, inviting us closer to determine if these ghostly figures are human or mythical beings. Careful study of the figures, their costumes, and paraphernalia unearths, however, a sinister element. Norman Lewis's abstract procession is actually a gathering of hooded figures on horseback. Even the title, *Evening Rendezvous,* takes on an ominous implication, alluding to the Ku Klux Klan and extremist groups who camouflage their actions by darkness and secrecy. The use of red, white, and blue most likely refers to their cloak of patriotism.

New York-born Lewis began his career during the 1930s as a social realist. He shifted from an overtly figural style, depicting bread lines, evictions, and police brutality, to non-objective abstraction in the 1950s, but remained active and consciously aware of social inequities, particularly those faced by African Americans.

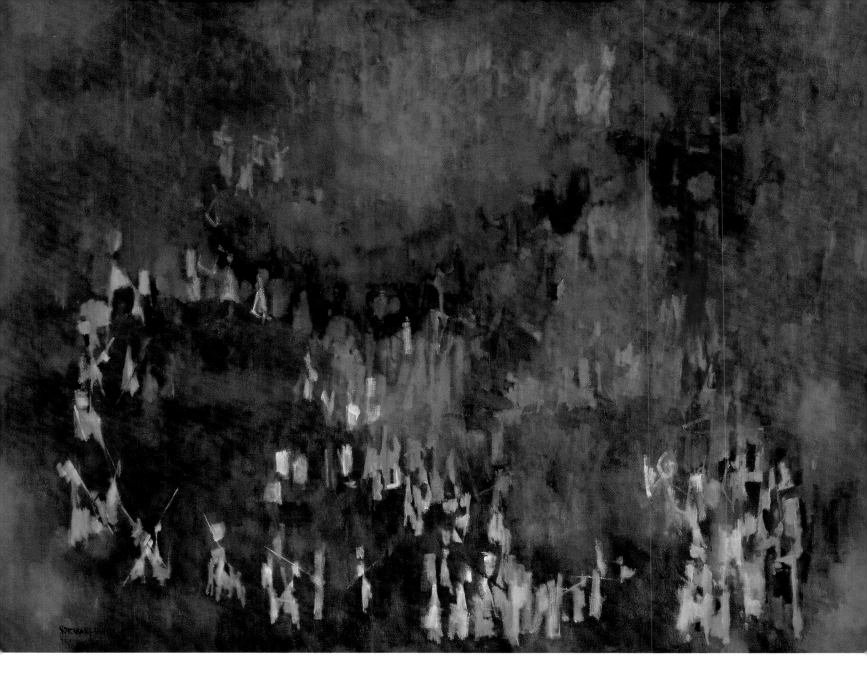

WHITFIELD LOVELL

born 1959

Echo I

1996, mixed
media on wood
80 ⅜ x 51 ¼ in.
Smithsonian
American Art
Museum, Gift of an
anonymous donor

Whitfield Lovell drew this figure directly on the plank wall of an abandoned row house in Houston, Texas. In homage to the home's former residents—families of railroad workers—Lovell's life-sized portrayal includes Depression-era clothing and hairstyles. This young woman, one of the imagined inhabitants, poses with her hand resting in her lap as the deep folds of her dress and ruffled scarf flow about her. Her cheerless expression suggests years of hard work, the signs of labor etched in her face. Hauntingly, she is both defined by and is an actual part of the wall that supports her. Lovell found inspiration for her pose and demeanor in photographs from the 1920s and 1930s, found in flea markets and antique shops. The warm browns of the wood, peeling paint, and wallpaper remnants also bring to mind vintage photos. In this life-size representation, Lovell creates a loving evocation of cultural memory.

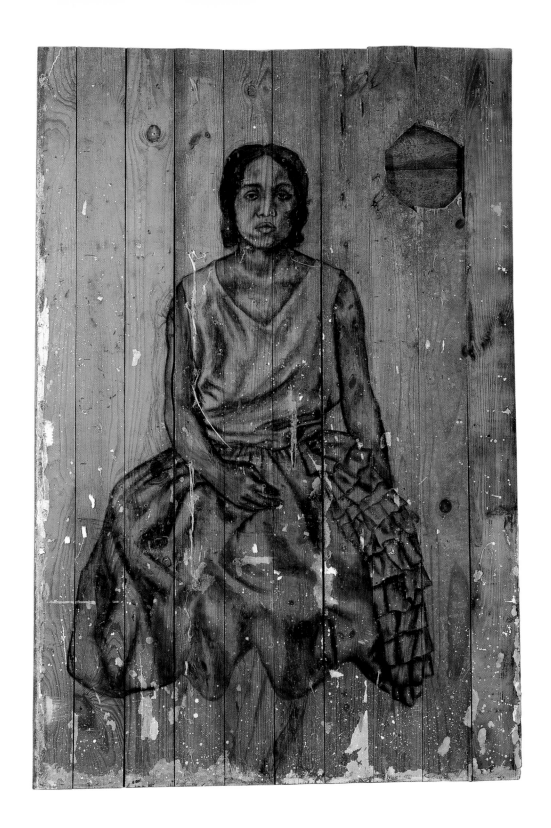

ROBERT McNEILL

born 1917

New Car (South Richmond, Virginia)

from the project *The Negro in Virginia*

1938
gelatin silver print
10 x 8 in.
Smithsonian
American
Art Museum,
Museum purchase

Who is the owner of this new car? No doubt it's the gentleman in the vest. His smile is broader and he caresses the vehicle with pride. His companions share his delight; one sits in the driver's seat. The laughing men and the shiny automobile draw the attention of young women who smile from the porch. Robert McNeill gives us a slice-of-life image by cropping the front of the car and the young man on the right. The unguarded expressions and gestures of the individuals in the foreground and background reinforce the sense of spontaneity.

A native of Washington, D.C., McNeill created this photograph while working on a federally sponsored project for the Works Progress Administration during the Depression. This lighthearted scene of young men admiring a new car emphasized shared moments of rare success at a time when unemployment and economic distress were common for most.

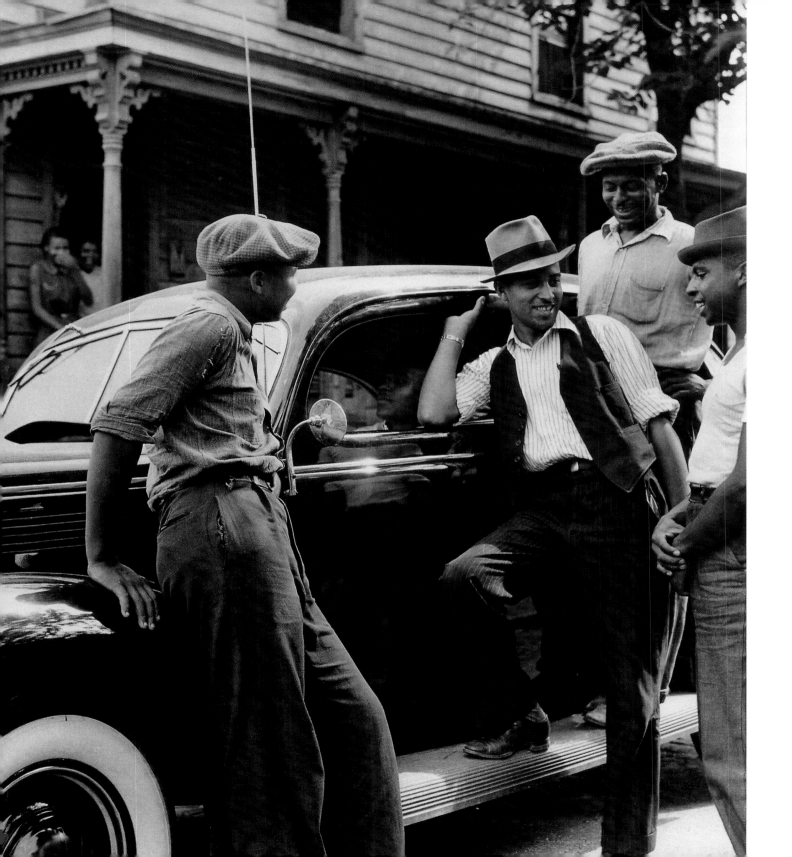

ROBERT McNEILL

born 1917

Spring Planting

from the project *The Negro in Virginia*

1938
gelatin silver print
9 ³/₈ x 7 ¼ in.
Smithsonian
American Art
Museum,
Museum purchase

This photograph of a plowman perched on a cultivator is compelling, both aesthetically and psychologically. His image dominates the picture plane. The brim of his hat shades his eyes, but we sense his concentration, as he holds the reins and instructs his team. Even the photographer's presence does not distract him from his task. The position of the plowman precariously balanced on his rig with no distance between him and the viewer conveys the tenuous position of black farmers and sharecroppers in the South during the 1930s.

McNeill's dignified image of a humble laborer was among a series of photographs he created for the 1940 publication, *The Negro in Virginia,* sponsored by the Works Progress Administration. Not only was the project the first WPA "state book" on African Americans, it was the product of the only all-African American unit of a statewide writers' project.

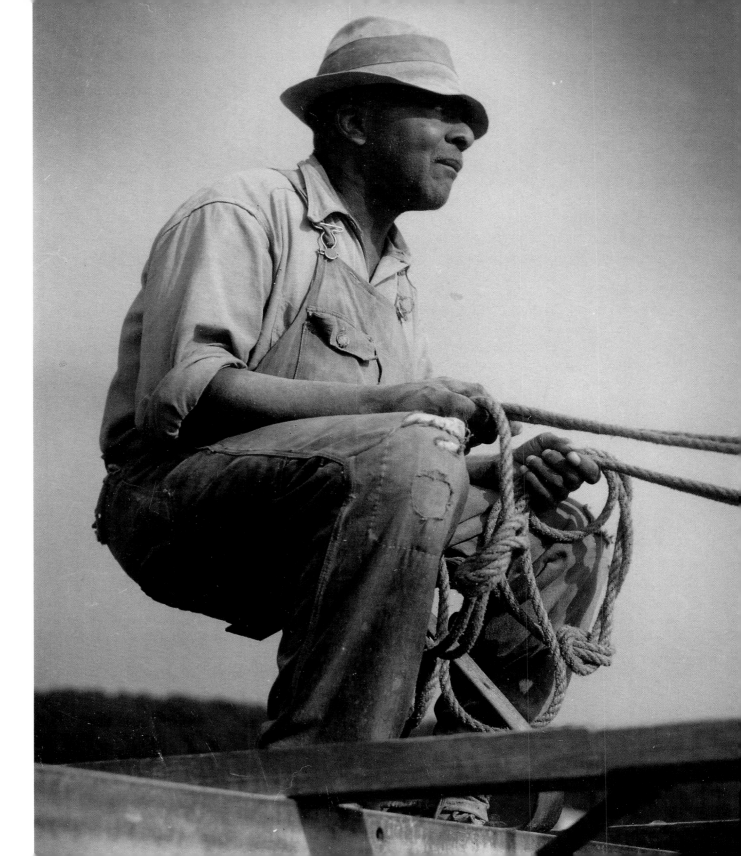

Fort Scott, Kansas

1950

gelatin silver print

13 ½ x 9 ½ in.

Smithsonian

American Art

Museum, Purchase

through the

Horace W. Goldsmith

Foundation

The people of Fort Scott, Kansas, have stayed with Gordon Parks all his life. He grew up in this prairie town, the youngest child in a family of fifteen, amid poverty and racism. In 1963 Parks published a moving autobiographical novel, *The Learning Tree*. During his childhood, he asked his mother if the family had to stay in Fort Scott forever, and she replied: "I don't know son, . . . but you're to let this place be your learning tree. Trees bear good fruit and bad fruit, and that's the way it is."

This image is among the many pictures of individuals and events Parks created of his hometown. An anonymous young man is lost in reverie, seemingly unaware of the photographer's presence. His bearing and expression and the closely cropped frame isolate him. The background is blurred, but the objects on the counter suggest the setting is a bar. Parks is a master of human observation and storytelling. He distills a world of experience and emotion into the way light and shadow play across the jaw, fedora, and bent hand. Parks called his camera his "weapon against poverty and racism." Parks's own determination and achievement suggest that this is not an image of an individual defeated, but one contemplating a way out.

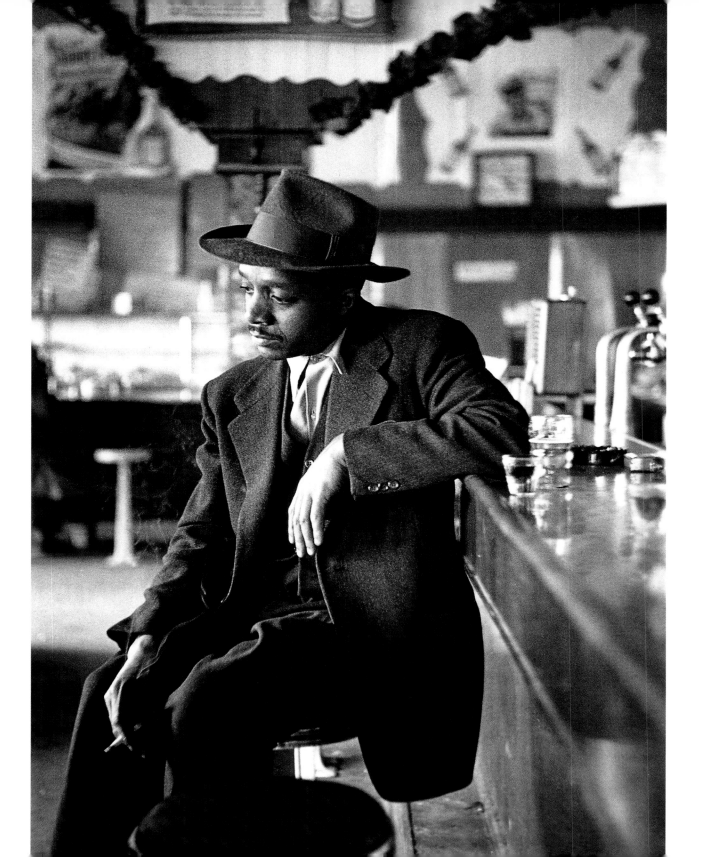

GORDON PARKS

born 1912

Muhammad Ali

1966
gelatin silver print
13 3/8 x 9 in.
Smithsonian
American Art
Museum, Purchase
through the
Horace W. Goldsmith
Foundation

Parks, who worked as a staff photographer for *Life* magazine from 1948 to 1970, covered rich and poor, black and white in his photographic essays. This multitalented artist has also found fame as a painter, writer, filmmaker, and musical composer. The shot of Muhammad Ali training in Miami, Florida, is among the images Parks produced while on assignment for *Life*. Invited by the magazine to cover the heavyweight champion's preparation for a match in London, Parks photographed Ali both in and out of the boxing ring. While Ali's face is instantly recognizable worldwide, Parks chose instead to focus on the boxer's grace and physical strength. He appears to levitate as the speed of his movement causes the jumping rope to blur. This unguarded moment also reminds us of Ali's flamboyant boast: that he could "float like a butterfly, sting like a bee."

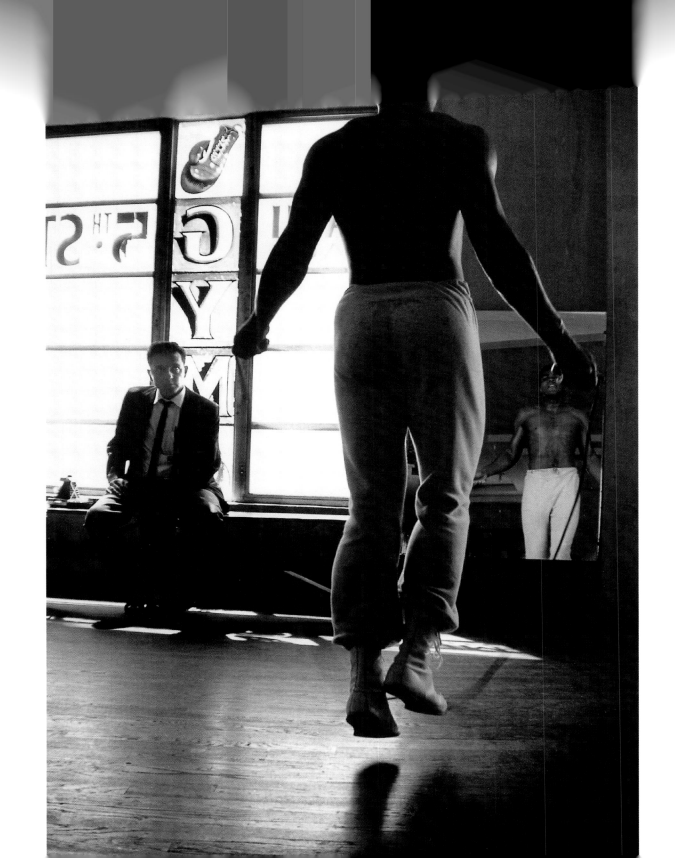

Old Black Joe

1943, oil
24 x 30 in.
Smithsonian
American Art
Museum, Purchase
through the
Luisita L. and Franz H.
Denghausen
Endowment

Horace Pippin's *Old Black Joe* is an interpretation of plantation life and the lot of African American slaves. "Joe," too old for fieldwork, lives out his last years tending a child whose mother watches from the porch of a stately mansion in the distance. The tether that connects him to the child reminds us that "Joe" was earlier bound to a life picking cotton in the fields that stretch behind him. Pennsylvanian-born Pippin derived this image and its title from Stephen Foster's Civil War-era ballad of the same name. The artist conveys the sense of loss that haunts the ballad's lyrics:

Gone are the days when my heart was young and gay/Gone are my friends from the cotton fields away/Gone from the earth to a better land I know/I hear their gentle voices calling "Old Black Joe."

Although primarily self-taught, Pippin's engaging narrative style led to national acclaim and to numerous commissions. The Capehart Division of Farnsworth Television and Radio commissioned the artist to paint this work for their collection and used it during World War II in a *Life* magazine advertisement to promote music's consoling power.

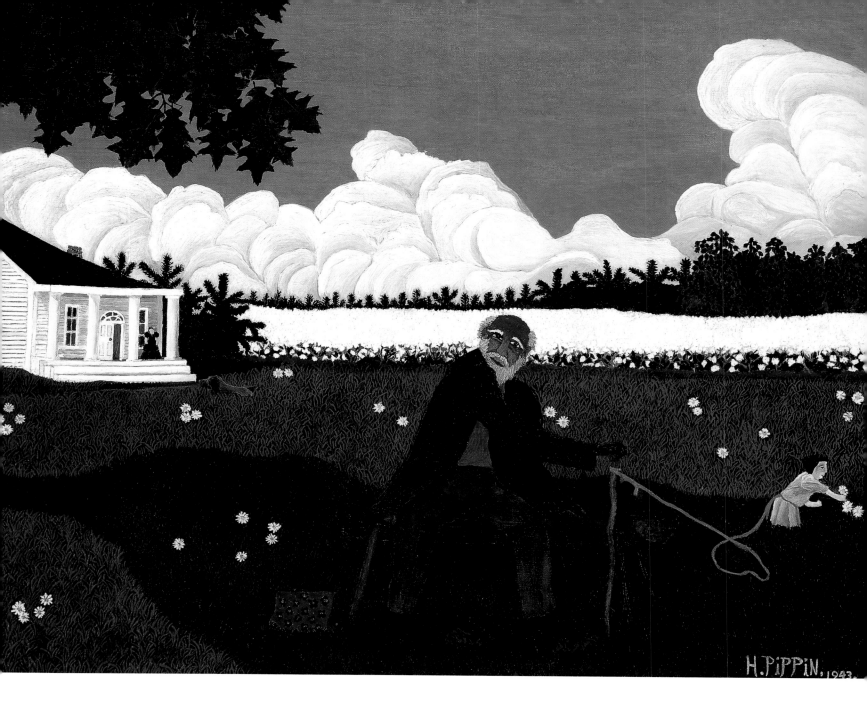

H.PiPPiN, 1943.

P. H. POLK

1898–1984

Portrait of Lillian Evans Tibbs (Evanti)

1937

gelatin silver print

10 3/8 x 8 in.

Smithsonian
American Art
Museum, Gift of
Thurlow Evans
Tibbs, Jr.

This stunning photograph accentuates the poise and refinement of Lillian Evans Tibbs. Professionally known as Madame Evanti, the internationally acclaimed lyric soprano was at the height of her fame when this photo was commissioned. The first black American to sing with the Paris Opera, Madame Evanti toured Europe where she charmed audiences during the late 1920s and early 1930s. Polk constructed her portrait in a formal manner. He recruited a Russian wolfhound to reinforce her cosmopolitan flair and emphasized her stature by shooting the portrait from below. The curve of the hound's back is reiterated in the bend of her arm, guiding the viewer to focus on her face.

Prentice Hall Polk studied photography at Tuskegee Institute in Tuskegee, Alabama. He later became the school's official photographer and maintained a studio in Tuskegee from 1939 until his retirement in the early 1980s. His photographs celebrate the national and local elite, as well as the working-class residents of the region.

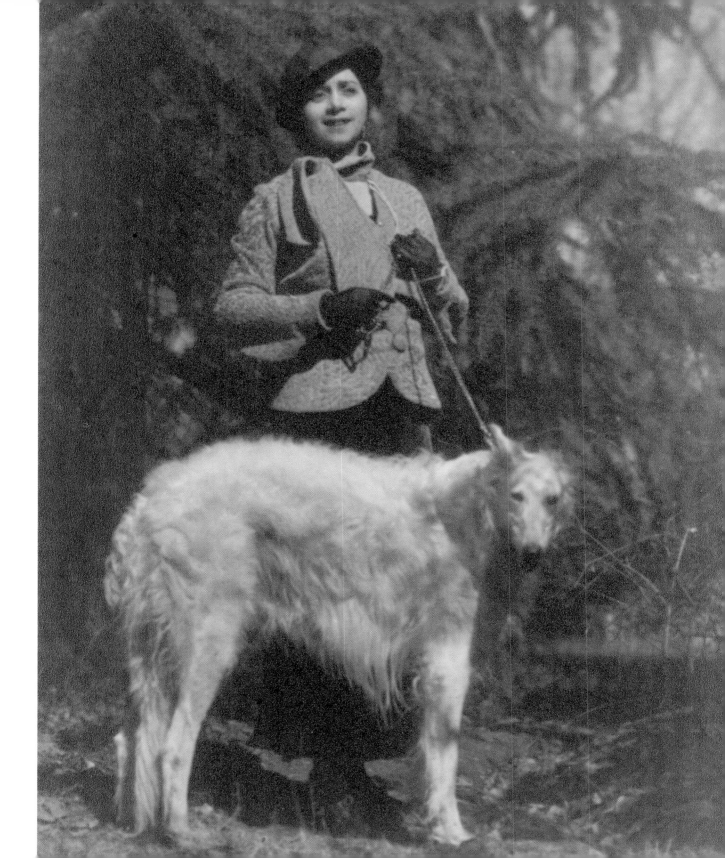

JAMES A. PORTER

1905–1970

Soldado Senegales

1935, oil
18 ⅛ x 14 ⅛ in.
Smithsonian
American Art
Museum, Purchase
made possible by
Anacostia Museum,
Smithsonian
Institution

Reportedly, this bust-length portrait depicts François Benga, the celebrated Senegalese dancer who starred at the Folies Bergère in Paris, using the stage name "Feral Benga." The performer also modeled for artists. He was the subject of a number of nude photographs by Platt Lynes and a celebrated sculpture by Richmond Barthé, as well as appearing in Jean Cocteau's 1930 film, *Blood of a Poet*. James Porter met Benga in 1935 during his sabbatical year while studying medieval archaeology at the Sorbonne in Paris. Rather than picturing the West African in one of his flamboyant dance moves, Porter portrays him as a military figure wearing the khaki-colored uniform and fez of the French colonial troops. Positioned firmly in the center of this composition, his head tilts slightly and he looks to his left past the viewer. This relaxed demeanor is how friends recall the performer, while the bold colors and energetic brushwork hint at the dancer's public persona.

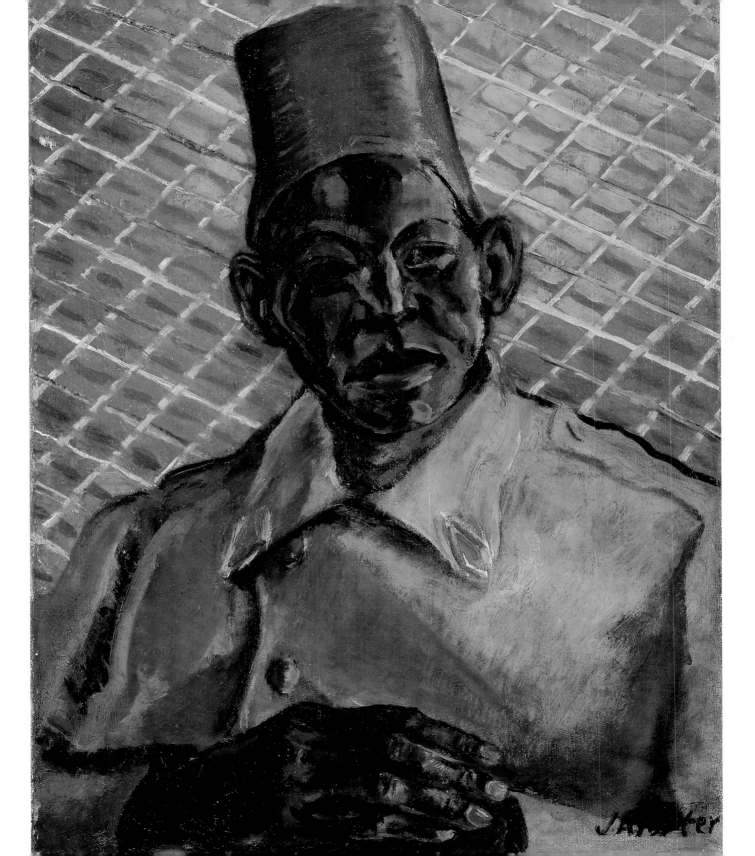

Still Life with Peonies

1949, oil

40 x 30 ⅛ in.

Smithsonian
American Art
Museum, Purchase
through the
Luisita L. and Franz H.
Denghausen
Endowment and the
Smithsonian
Institution
Collections
Acquisition Program

Lush peony blossoms spill over the container that sits atop a pedestal table. The artist's wife, Dorothy Porter, fondly recalled the day the work was created in 1949, when she was honored as "Alma Mater" at Howard University's May Festival. For the occasion, she carried a large bouquet of peonies. Upon returning home, her husband quickly retrieved the flowers and arranged them near a stair landing and began painting. This homage to his wife also typifies themes that interested Porter throughout his career. The domestic accessories hint of family and friends, who appeared often in his canvases, while the genre scene at the lower right refers to his study of the Black Diaspora in the Caribbean, Mexico, and Europe.

The multi-talented Porter was an artist, scholar, educator, and mentor. He is recognized as the first African American art historian; his 1943 publication, *Modern Negro Art,* is the earliest comprehensive treatment of the contributions of artists of African descent to American art and culture.

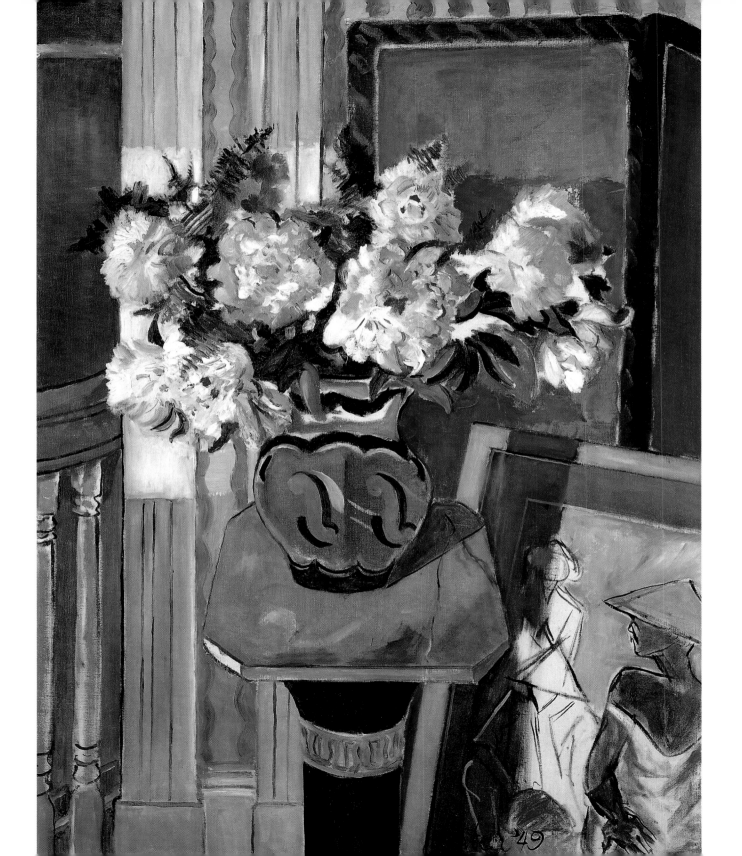

FAITH RINGGOLD

born 1930

The Bitter Nest, Part II: The Harlem Renaissance Party

1988, acrylic with
printed, dyed, and
pieced fabric
94 x 83 in.
Smithsonian
American
Art Museum,
Museum purchase

Faith Ringgold's tumultuous relationship with her two daughters inspired the drama that unfolds in her series entitled *The Bitter Nest.* Initially a performance piece, the artist eventually painted the tale of family differences and intrigue on grids and panels of fabric pieces that were then stitched together to form five quilts. Referring to the narrative as a "fantasized adaptation of real life," the artist set the story in Harlem during the 1920s. Cee Cee, the story's heroine, cannot speak or hear. Married to a prominent dentist, the socialite is famous for giving splendid dinner parties, where she entertains her guests in odd-looking, homemade costumes. Her daughter, Celia, is distraught by her mother's behavior and considers her "crazy like her quilts." Here, she stares in horror as her mother flamboyantly dances during a dinner for Harlem's elite, including writer Langston Hughes, scholar W.E.B. Du Bois, critic and art collector Alain Locke, and entertainer Florence Mills.

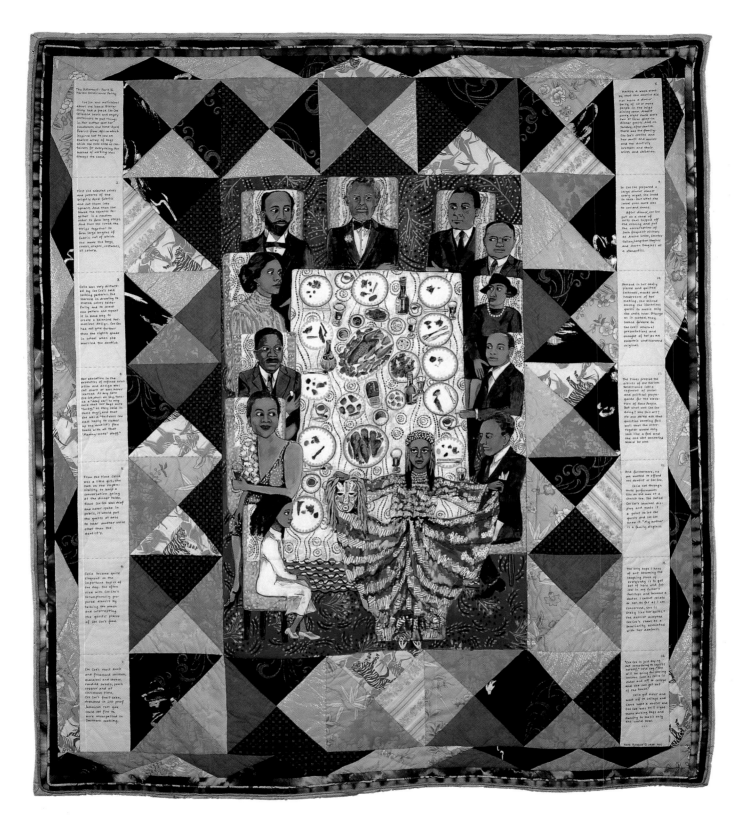

BETYE SAAR

born 1926

Wishing for Winter

1989, mixed media
40 ¾ x 19 ¼ x 2 ¼ in.
Smithsonian
American Art
Museum,
Museum purchase

Betye Saar incorporates gloves, keys, butterfly wings, feathers, a book, and change purse in this assemblage poetically entitled *Wishing for Winter*. Sandwiched between glass and a wooden window frame, these shadowy objects prompt several questions. Are these objects the nostalgic detritus of a private life? Or do they evoke collective memories of a shared past? Actually Saar rarely goes in pursuit of specific objects for her assemblages. Instead she trusts in the objects finding her, either from the trove of personal and family mementos that filter down or from collections of cast-off objects imbued with others' histories found at swap meets.

The window has been a significant motif in Saar's work for nearly thirty years. According to the artist, the window is "like the physical looking into the spiritual." The Los Angeles native finds inspiration in her personal history, the African American experience, and mystical ideas from cultures worldwide.

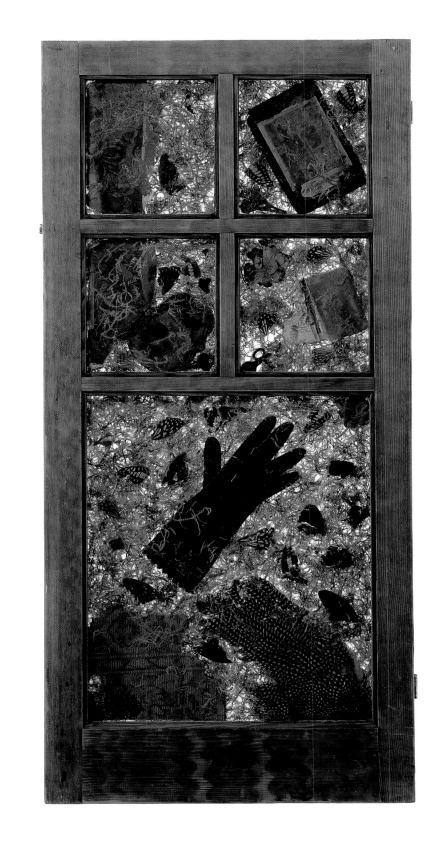

AUGUSTA SAVAGE

1900–1962

Gamin

about 1929
painted plaster
9 x 5 ¾ x 4 ⅜ in.
Smithsonian
American Art
Museum, Gift of
Benjamin and Olya
Margolin

Augusta Savage convincingly captures the rebellious nature of this young man, reputedly her teenage nephew, Ellis Ford, who lived in Harlem. Wearing a wide-brimmed cap cocked to the side, he casually leans to the side and boldly stares past the observer. His sullen expression underscores his defiant posture. Scratched in the base is the French word, "Gamin." The term refers to street-wise children who often appeared in nineteenth-century literature and painting.

This small sculpture was modeled in clay and cast in plaster. The artist often didn't have enough money to have every one of her pieces metal cast so she painted the plaster to resemble bronze. It is one of several surviving plasters of the life-size bronze, one of Savage's best-known works. The recognition this work brought her included the award of a scholarship that allowed her to study at the Académie de la Grande Chaumière in Paris.

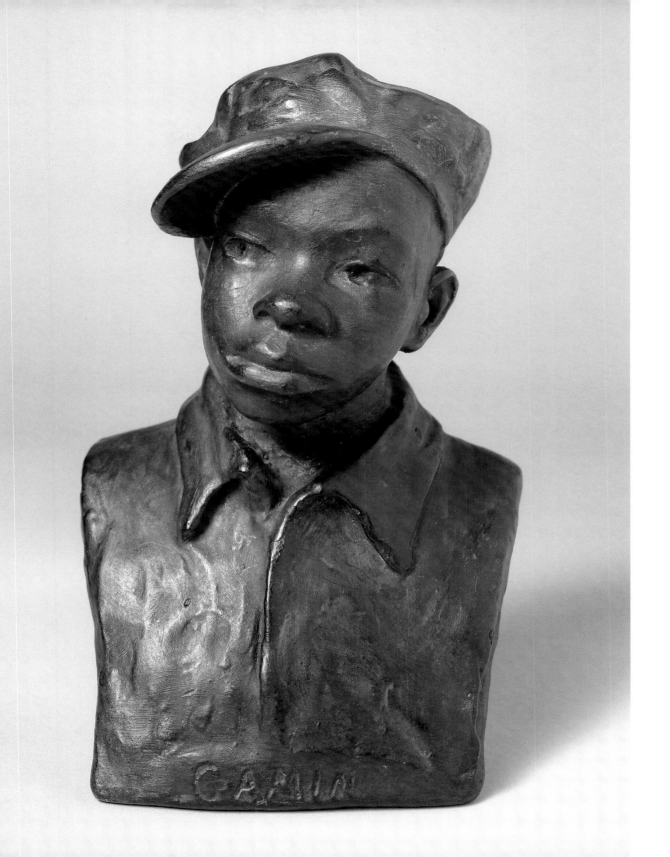

RENÉE STOUT

born 1958

The Old Fortune Teller's Board

1993, painted wood, watercolor and ink on paper, mudfish bones, and leather
4 x 23 ⅞ x 23 ⅜ in.
Smithsonian American Art Museum, Purchase made possible by Ralph Cross Johnson and Mrs. William Rhinelander Stewart

A mysterious woman in Renée Stout's former Pittsburgh neighborhood inspired *The Old Fortune Teller's Board*. Stout never met "Madam Ching" or ventured inside her establishment, but the artist imagined the special paraphernalia—a mystical board, emblematic cards, and magic bones—the fortuneteller used to practice the art of divination. Stout convincingly constructed these items. The mudfish bones, however, are original. They are from Africa and were a gift from a friend. According to the artist, "nothing on the board is evil." Only positive readings are possible here.

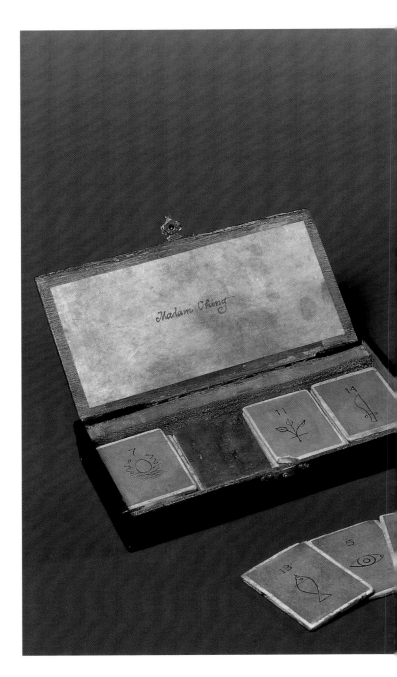

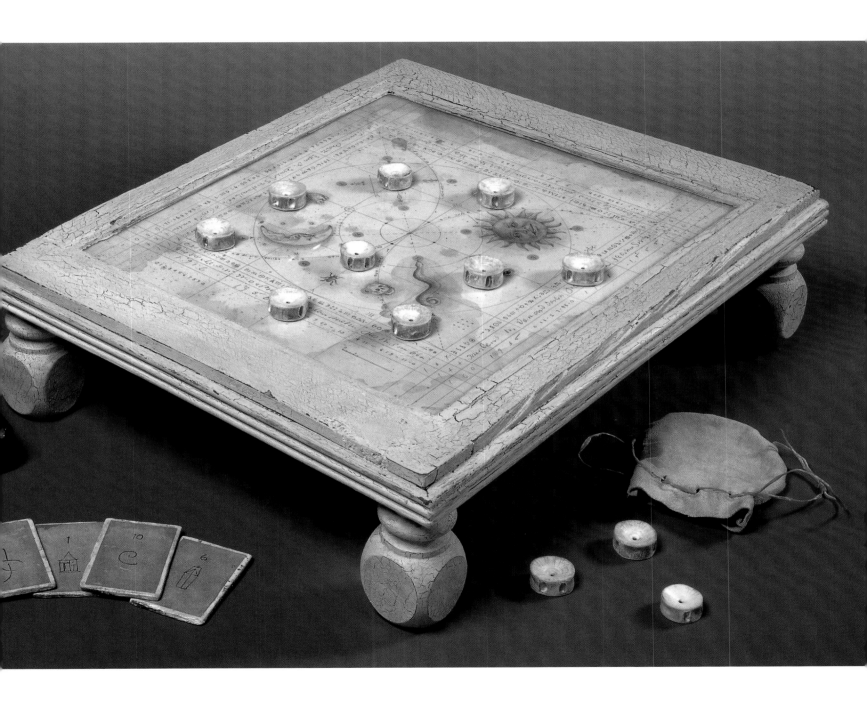

HENRY OSSAWA TANNER

1859 USA–1937 France

Fishermen at Sea

about 1913, oil
46 x 35 ¼ in.
Smithsonian
American Art
Museum, Gift of
Jesse O. Tanner

We experience a bird's eye perspective on man's classic struggle with the sea as a boat valiantly heads into high waves against the wind. The prow rises at a steeply pitched angle that conveys a strong sense of motion and danger. Small, indeterminate forms in expressive swirls of pink and black suggest a figure clinging to the rudder and others huddling beneath the mast and toward the rear. Dark, inky shades of blue move upward into aquamarines capped by pastel bands, one icy the other golden. Tanner's renowned command of the color blue describes the sea as a palette of shifting forces, moods, and colors.

The son of a famous African American minister, Tanner brought a deeply spiritual viewpoint and knowledge of the Bible to his paintings. While some works take their inspiration from specific Biblical incidents and characters, others stand as parables of man's struggle in the world, here loosely based on either Jonah's trials at sea or Christ and his disciples on the Sea of Galilee.

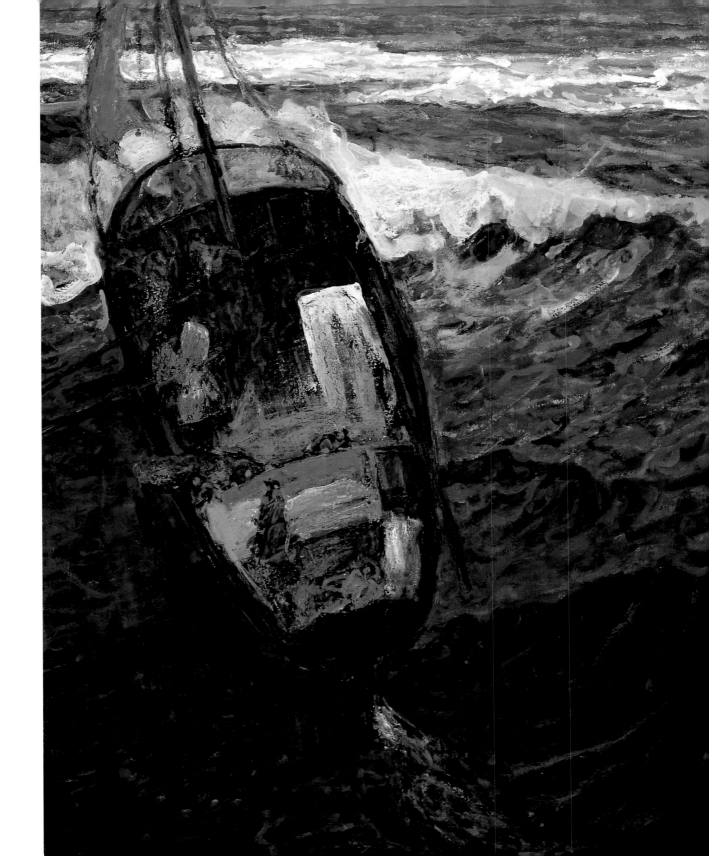

ALMA THOMAS

1891–1978

Red Sunset, Old Pond Concerto

1972, acrylic
68 ½ x 52 ¼ in.
Smithsonian
American Art
Museum, Gift of the
Woodward
Foundation

Mosaic patches of red paint, applied in broad strokes, cover this canvas. Dappled areas of gray and blue-black offset the colored squares, triangles, and rectangles. The visual effect creates a jewel-like pattern that is ever changing. Vertical bands that divide the canvas imply movement, and dark and light stripes gradually shift, becoming one ripple across the painting's surface.

Alma Thomas began her fine arts studies in the field of costume design but gradually shifted her focus to painting. She called these abstract patterns "Alma's stripes" or "earth paintings" but gave them realistic titles. Nature and music fascinated her. She often referred to these two influences when giving the paintings their titles. Perhaps it was the shimmering shades of sunset on the water of a local pond that inspired this work.

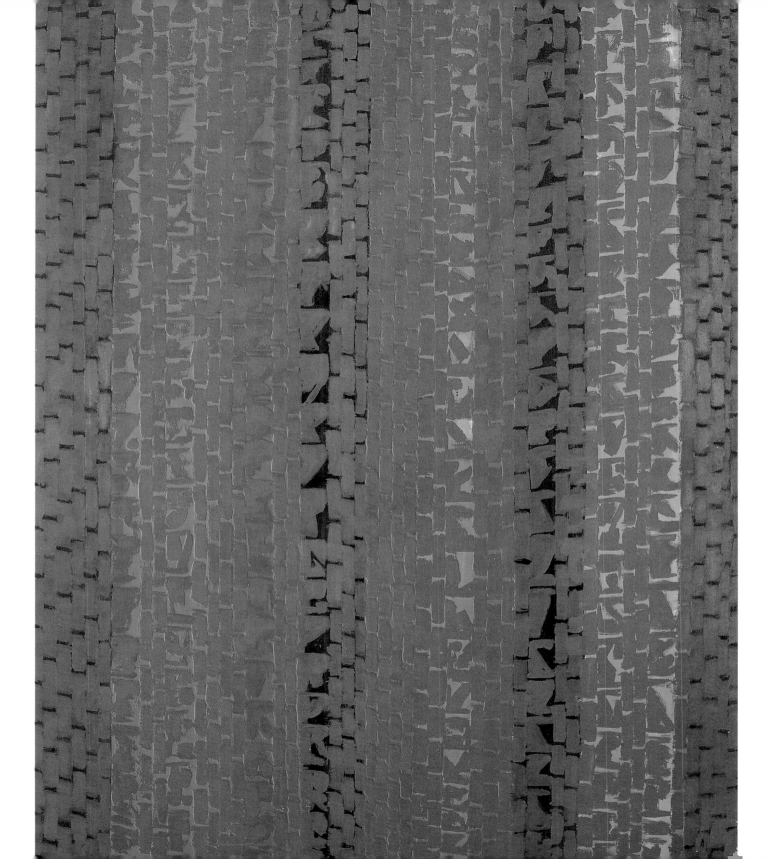

BOB THOMPSON

1937 USA–1966 Italy

Descent from the Cross

1963, oil
84 x 60 ⅛ in.
Smithsonian
American Art
Museum, Gift of
Mr. and Mrs.
David K. Anderson,
Martha Jackson
Memorial Collection

Intense reds, yellows, and blues dominate this image of kneeling figures mourning the death of Christ. Colorful diagonals flatten the background and focus attention on the silhouetted figures that kneel, sit, lie, and fly in the foreground. Accents of color vibrate and punctuate the composition, creating a visual rhythm that moves the eye up and down and across the painting's surface. Fantastic winged creatures complete this dramatic scene. Bob Thompson combines traditional Christian religious imagery and fantasy in this expressive, highly personal painting.

More than half of Thompson's short nine-year career was spent in Europe, a time that was to leave its mark on his choice of subject matter. In what he called "head-on confrontations," Thompson lifted particular passages or often entire compositions from the works of masters of the European tradition.

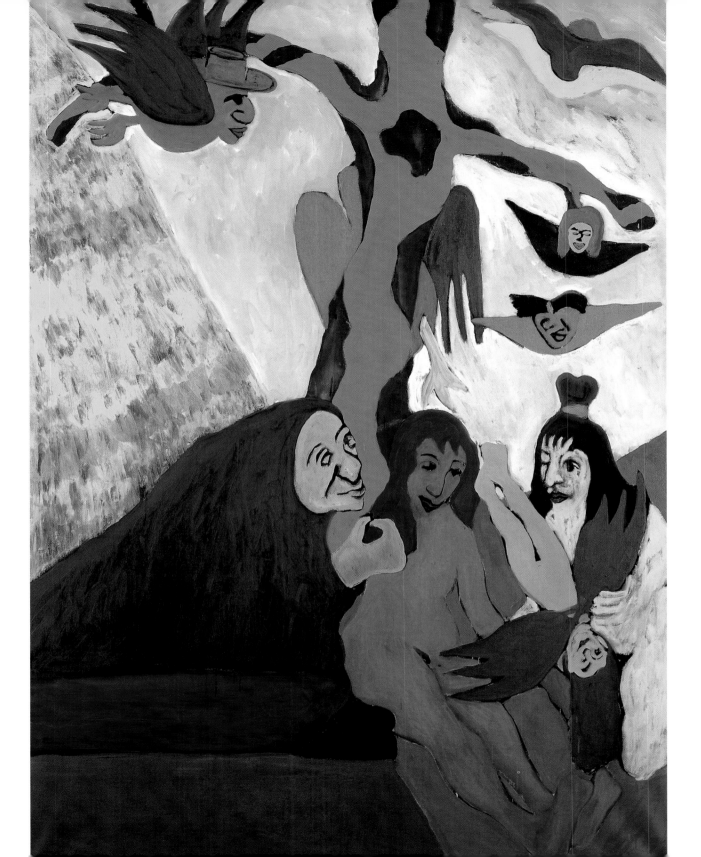

JAMES VANDERZEE

1886–1983

Evening Attire

1922
gelatin silver print
10 x 8 in.
Smithsonian
American Art
Museum, Purchase
through the Julia D.
Strong Endowment
and the
Smithsonian
Institution
Collections
Acquisition Program

Evening Attire is typical of James VanDerZee's ability to endow his sitters with a sense of style and dignity. Flaunting a fur wrap, broad-brimmed hat, and an elaborate evening dress, this fashionable young woman exudes a confident, self-assured air. Seemingly at home in this comfortable setting, she cradles a floral bouquet, while fixing her gaze directly at the lens.

VanDerZee began photographing as a teenager after having won an eight-dollar camera as a premiun for selling pink and yellow silk sachets. Beginning in 1916 he worked out of a commercial Harlem studio he opened on 135th street. During the 1920s and 1930s, he produced hundreds of photographs recording Harlem's growing middle class. Its residents entrusted the visual documentaion of their weddings, funerals, celebrities, and social life to his carefully composed images. VanDerZee knew the neighborhood and its inhabitants, and shared their dreams and aspirations for self-determination and racial pride.

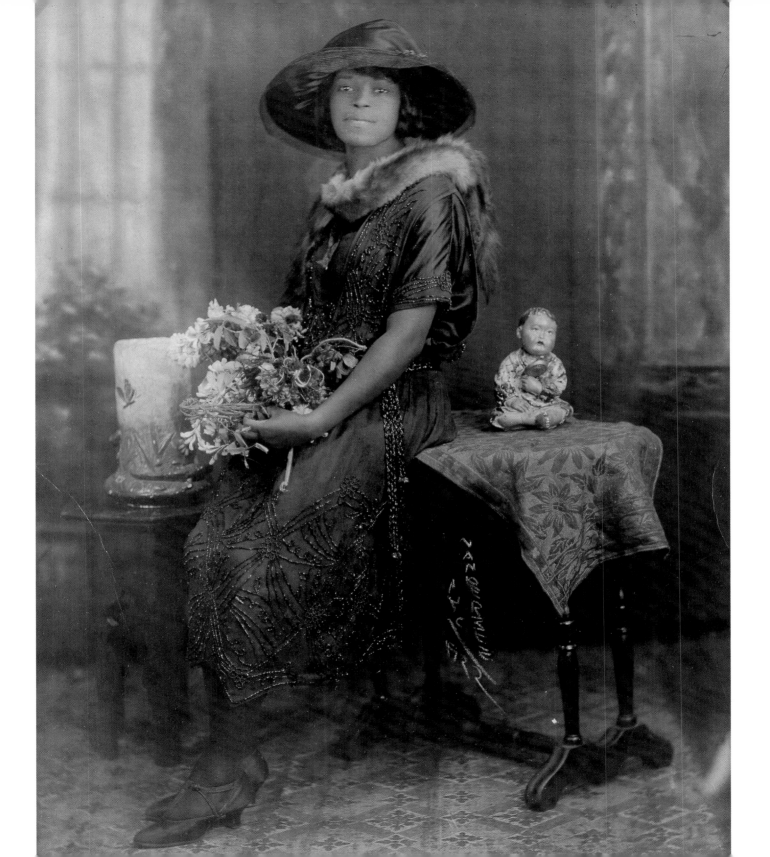

JAMES VANDERZEE

1886–1983

GGG Photo Studio at Christmas

1933, hand-colored
gelatin silver print
8 x 10 in.
Smithsonian
American Art
Museum, Purchase
through the
Julia D. Strong
Endowment
and the
Smithsonian
Institution
Collections
Acquisition Program

In addition to his numerous studio portraits of individuals, VanDerZee also specialized in group photographs. This gathering of children at Christmas attests to his finesse in photographing youngsters. Undistracted by their unwrapped presents or the twinkling lights on the tree behind them, they patiently stare at the camera. Only one young man, on the far left, places a hand under his chin, as if to challenge the photographer to hurry up and get through with his task.

"GGG Photo," VanDerZee's second photography studio, was named in honor of his second wife, Gaynella Greenlee. Located at 272 Lenox Avenue in Harlem, the studio thrived as individuals from all walks of life appreciated his innovative techniques, including hand tinting and retouching images. In the 1940s, however, with the advent of the handheld camera, his business would begin to dwindle. As he said, "Brownies made everybody a photographer."

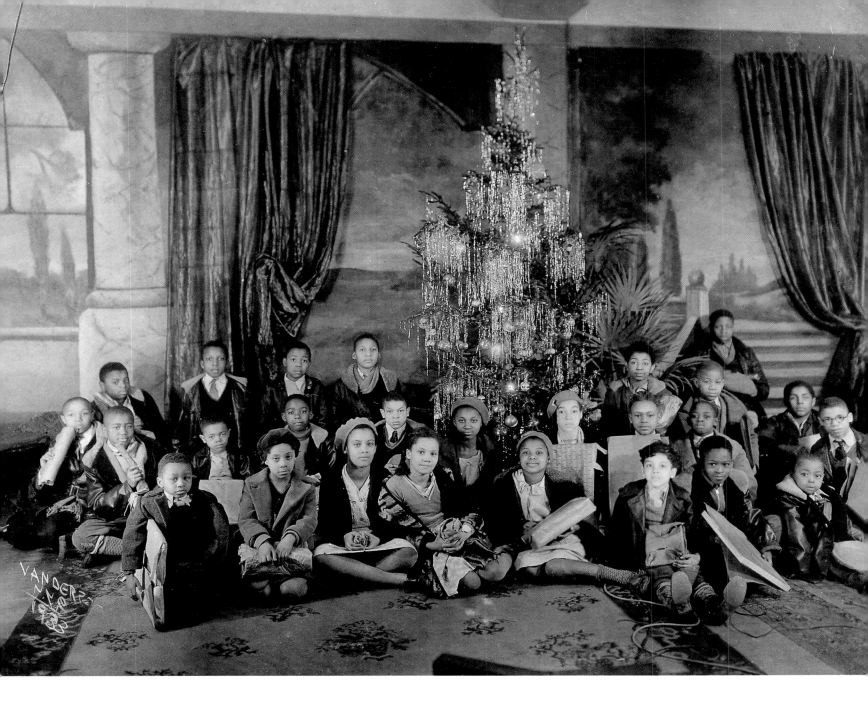

JAMES VANDERZEE

1886–1983

Studio Portrait of Young Man with Telephone

1929

gelatin silver print

9 x 7 ½ in.

Smithsonian

American Art

Museum, Purchase

through the

Julia D. Strong

Endowment

and the

Smithsonian

Institution

Collections

Acquisition Program

These elegant furnishings—the Edwardian table and chinoiserie objects—are studio props. It is likely that the photographer also provided the young man's stylish attire. VanDerZee's well-stocked studio was legendary. Sitters could select garments, backdrops, furnishings, and architectural elements to enhance their social standing or even to construct new identities. The added prop of the telephone attests to the young man's advanced technological capabilities. It is a commentary on VanDerZee's abilities as a studio photographer that, given all these alien accoutrements, the sitter appears at ease and at home in his surroundings. Whether this setting is real or imagined, the fashionable young man epitomizes the optimistic attitude associated with the era between the World Wars commonly referred to as the Harlem Renaissance. VanDerZee's carefully composed photographs reflected his clients' self-reliance and material comfort while characterizing a difficult time as one of achievement and promise.

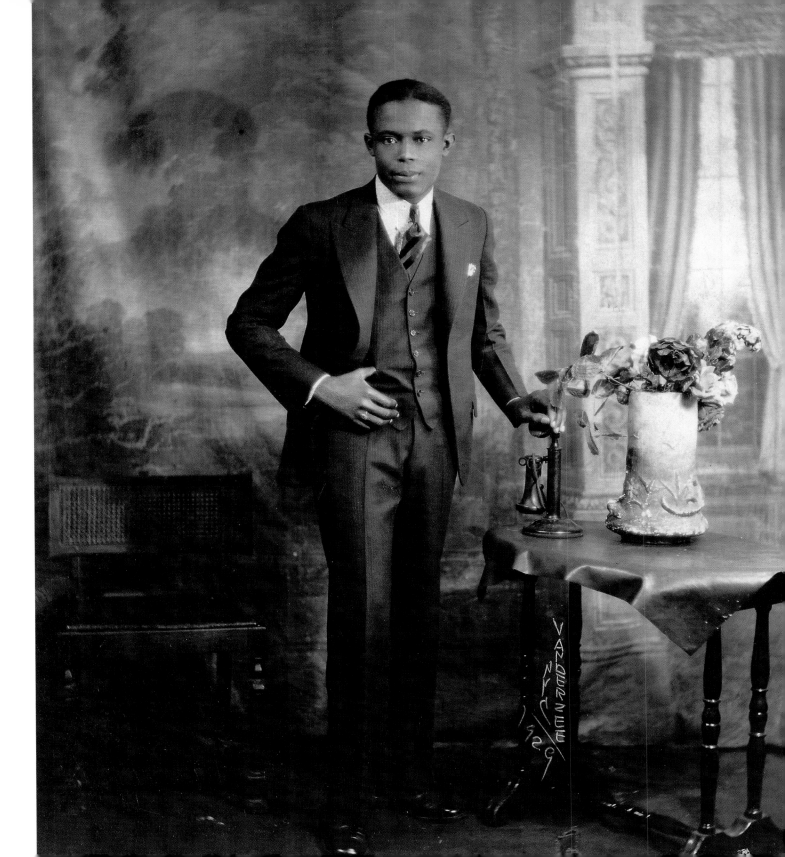

HALE WOODRUFF

1900–1980

Georgia Landscape

about 1934–35, oil
21 ⅛ x 25 ⅝ in.
Smithsonian
American Art
Museum,
Gift of Mr. and Mrs.
Alfred T. Morris, Jr.

Nothing is at rest in Woodruff's vortex of shifting soil and menacing foliage. Yellows, reds, blues, and greens activate the ground, transforming it into abstract, curvilinear patterns that float and surge among the twisting trees. Short, measured brushstrokes suggest the wind's force swirling through serpentine limbs and leafy boughs. His expressive style is bold and muscular.

Hale Woodruff was a socially active artist who, along with other artists such as the Washington painter Felrath Hines, formed the group Spiral as a circle in which to meet and discuss issues relevant to African American artists. As an educator Woodruff always encouraged his students to paint what they knew, and he certainly followed this advice himself. He made frequent sketching trips in the Atlanta area and this is one of several landscapes inspired by those expeditions. His interpretation of the red clay, spindly pines, and gnarled oak capture the region's distinctive features.

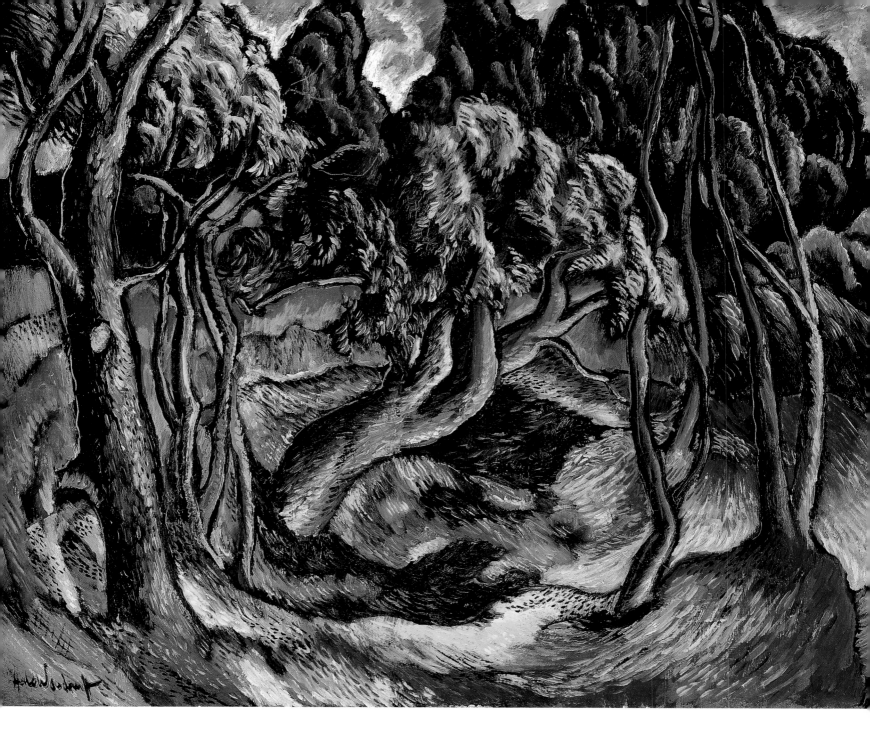

PURVIS YOUNG

born 1943

Untitled

about 1988
acrylic on plywood
40 ½ x 48 ¼ in.
Smithsonian
American Art
Museum,
Museum purchase

Frenetic squiggles and calligraphic lines combine in an image that hovers between realism and abstraction. A herd of majestic horses dominates the composition's center. Surrounding this panel are pieces of wood painted with smaller scenes of standing and prone figures and a semi-truck. Throughout this mixed-media piece, Purvis Young presents us with oppositions. The spirited horses seem capable of flight, one actually winged, while the figures are isolated and trapped in box-like cells, seemingly unaware that the horses and truck offer an escape from the maze. Young's message is powerful—a way out can exist in the midst of turmoil and struggle.

Purvis Young mines the construction sites and vacant lots of his Overtown neighborhood in Miami, Florida, for discarded plywood and scraps of lumber. His images are inspired by his personal visions and the culturally rich environment of his community, home to large communities of Haitian and Cuban immigrants.

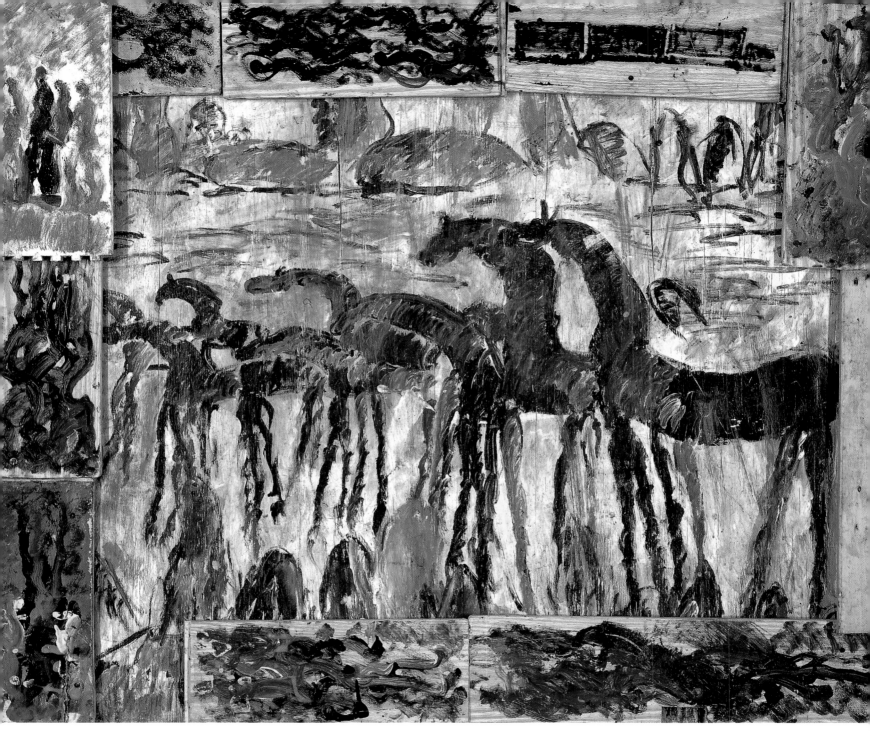

Index of Titles

Sources of Quotations

p. 10: *Hats and Hat Nots* (New York: Queensborough Community College Art Gallery, 1993), n.p.

p. 18: "The Symbol of the Shotgun House," *The Web of Life: The Art of John Biggers. A Conversation with John Biggers.* getty.edu/artsednet/resources/Biggers/conv/shotgun

p. 20: *Three Masters: Eldzier Cortor, Hughie Lee-Smith, Archibald John Motley, Jr.* (New York: Kenkeleba Gallery, 1988), 15

p. 24: Joy Chambers, *Jazz Photos at the Museum of Modern Art? How it Happened* (New York: Jazz Journalist Association, 2001), n.p.

p. 40: Romare Bearden and Harry Henderson, *A History of African-American Artists from 1792 to the Present* (New York: Pantheon, 1993), 159

p. 42: Joe Shannon and Ed Love, *Options* (Washington: Washington Project for the Arts, 1983), n.p.

p. 48: *San Francisco Chronicle,* 6 Oct. 1935; cited in *Sargent Johnson: Retrospective* (Oakland: The Oakland Museum Art Division Special Gallery, 1971), 17

p. 50: Thomasius, "Dagens Interview: Med Indianer-og Negerblod I Aarene. Chinos-Maleren William H. Johnson fortaeller lidt om sin Afrikarejse, primitiv Kunst, m.m.," *Fyns Stiftidende* (Odense, Denmark), 27 November 1932, 3

p. 64: Carol Wald, "The Metaphysical World of Hughie Lee-Smith," *American Artist* (October 1978): 101

p.74: Gordon Parks, *Voices in the Mirror: An Autobiography* (New York: Doubleday, 1990), 66

p. 84: Private correspondence, Dorothy Porter Wesley to Lynda Roscoe Hartigan, 1 July 1994, SAAM curatorial files

p. 86: Faith Ringgold, *We Flew Over the Bridge* (Boston: Bulfinch, 1995), 254

p. 88: Channing D. Johnson, "Betye Saar's Voodoo World of Art," *Essence Magazine* (March 1976): 85

p. 92: Gwen Everett, conversation with Renée Stout, October 29, 1996, SAAM curatorial files

p. 96: Merry A. Foresta, *A Life in Art: Alma Thomas, 1891–1978* (Washington: Smithsonian Institution Press, 1981), 23; Ralph M. Hudson, *Black Artists/South* (Huntsville, Ala.: Huntsville Museum of Art, 1979), 50

p. 98: *Bob Thompson at the Whitney Museum,* exhibition brochure (New York: Whitney Museum of American Art, 1998), n.p.

p. 102: africanpubs.com/Apps/bios/0923VanDerZeeJames